IMAGES
of America

SWISS IN
GREATER MILWAUKEE

MW00612574

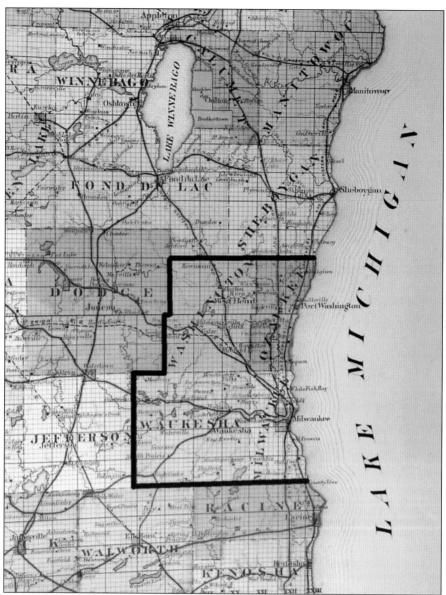

FOUR COUNTY AREA. The Greater Milwaukee area includes Milwaukee, Waukesha, Washington, and Ozaukee Counties and more than 93 communities in southeastern Wisconsin. The area is surrounded by Dodge, Fond du Lac, and Jefferson Counties, which also had a considerable number of Swiss inhabitants by the late 1840s. Historically this region was interrelated in economical, cultural, social, religious, and political matters. (Photograph by Maralyn A. Wellauer-Lenius, courtesy of the Waukesha County Historical Society and Museum.)

ON THE COVER: The *Helvetia* Society of Milwaukee is on stage about 1893. *Helvetia* (center) is the national personification of Switzerland. This female symbol of liberty, which is similar to the symbolic figure of the American Lady Liberty, dates back to the late 1600s. Her shield is emblazoned with the official Swiss coat of arms. Switzerland (the Swiss Confederation) in Latin is officially called "*Confoederatio Helvetica.*" (Courtesy of the Milwaukee County Historical Society.)

IMAGES
of America

SWISS IN
GREATER MILWAUKEE

Maralyn A. Wellauer-Lenius

ARCADIA
PUBLISHING

Published by Arcadia Publishing
Charleston SC, Chicago IL, Portsmouth NH, San Francisco CA

Printed in the United States of America

Library of Congress Control Number: 2010929098

For all general information contact Arcadia Publishing at:
Telephone 843-853-2070
Fax 843-853-0044
E-mail sales@arcadiapublishing.com
For customer service and orders:
Toll-Free 1-888-313-2665

Visit us on the Internet at www.arcadiapublishing.com

*As always, I dedicate my work to the memory of my beloved
parents, George R. and Maude W. Wellauer, and to my
husband, Brian J. Lenius—the dearest and the best.*

CONTENTS

ACKNOWLEDGMENTS

Grateful thanks are extended to the past and present members of Milwaukee's Swiss societie who faithfully preserved the history of their organizations. And thanks to those who shared their images and stories for this book and helped identify elusive people and places.

The photographs and accounts presented in the following pages tell the stories of a few Swis men and women who made the perilous journey across the ocean and settled in southeasterr Wisconsin. Some of us believe they made it a better place. To all the Swiss who have passed before us, whose stories and images did not make it onto the pages of this book, you are not forgotten.

For additional photographs, suggestions, and expertise, my appreciation to the following: Rose Fortier (photograph librarian), Humanities Department, Milwaukee Public Library; Steven Daily (curator of research collections) and Amanda Lang, Milwaukee County Historical Society; Lisa Marine (business manager) and Dee Anna Grimsrud (reference archivist), Wisconsin Historica Society; Kevin Kurdylo (librarian), Max Kade Institute for German-American Studies; Shelly M Solberg, Archdiocese of Milwaukee Archives; Heather Przybylski, Washington County Historica Society; Tom Ramstack (author and teacher); John Schoenknecht (retired Waukesha teache and editor of the *Landmark*); Alexander P. Durtka Jr. (president of the International Institute c Wisconsin); Susan Ploetz (librarian); and to Irène Neff, Emmely Gideon, and Mary A. Cante for their assistance and suggestions.

And finally, I would like to acknowledge the love, support, and valuable assistance to thi project provided by my husband and best friend, Brian J. Lenius.

INTRODUCTION

When George Wild arrived in Milwaukee from Switzerland in 1837, Solomon Juneau, Byron Kilbourn, and George H. Walker, three headstrong frontier lords, presided contentiously over the emerging city. Historian Dr. Adelrich Steinach stated in 1889 that Wild was the first Swiss in Milwaukee, and there is no evidence to the contrary. It is impossible to speculate about what attracted this early traveler (a carpenter and later a farmer) to the area. The township of Milwaukee had just been organized in September 1835, and there were only approximately 39 voters at the time. The village of Milwaukee was incorporated early in 1837, but it was still a raw, untamed place. There were many opportunities for strong, enterprising folks, and they came. The average Swiss man or women found it difficult to improve their social or economic status in Switzerland. For these reasons mainly, they became part of a wave of Swiss immigration that commenced during the first half of the 19th century and lasted until the mid-20th century.

Swiss immigrants also settled nearby Waukesha and Washington Counties in the 1840s, where they found inexpensive and fertile farmland. The settlement in Brookfield (Waukesha County) had the largest concentration of Swiss outside Milwaukee. In addition to those mentioned herein, we find the names Amman, Anderegg, Holz (Holzer), Honzler, Klein, and Martin on census rolls.

Washington County was created on December 7, 1836. The county's legendary Rev. Caspar Ruegg (1837–1915) and honorable Justice John Liver (1819–1891) deserve special mention in addition to others in this book. Born in Zürich, Ruegg was a wood-carver who decided to study for the ministry. He immigrated in 1866. Two years later, he was called to Christ Church (German Evangelical) in Germantown. He was the first pastor at St. John's in Germantown, organized St. Paul's in Menomonee Falls, St. Jacob's in Jackson, and conducted services in the schoolhouse at Mayfield. When he died, Ruegg was considered almost a saint by his parishioners. His wife, Amalia Zimmermann, was Swiss. Johann (John) Georg Liver was born in Sarn, Graubünden, and went to Washington County in 1849 to farm. He removed to Milwaukee in 1871, where he was a notary public and was elected justice of the peace. His wife, Eva, was also Swiss.

Ozaukee County (originally named Tuskola) was split off from the south end of Washington County in 1850. It became the smallest county (in area) in the state. Few Swiss populated Ozaukee County. The following is a list of some family names that appeared on the decennial census schedules: Frick in Grafton; Hilty and Voight in Mequon; Conrad, Kirchhofer, Kopp, and Roethlisberger in Fredonia; Stockli in Saukville; Schaub and Roth in Cedarburg; and Naef in Waubeka.

The Swiss in the four county area can be understood best through stories of their individual accomplishments and the histories of their societies. They established a number of groups that fostered, promoted, and taught Swiss dialects, music, songs, and culture. In 1849, Friedrich and Christian Herrmann founded the first singing society, *Frohsinn* (predecessor of the *Schweizer Männerchor*), in Milwaukee. By the outbreak of the Civil War, there were several other Swiss singing societies. The first Swiss band was assembled in 1850. Men and women's singing societies would perform together in concert with interludes by the bands. Groups were disbanded at the outbreak of the Civil War in 1861.

A shooting society, *Helvetia Schützengesellschaft*, was organized in April 1854. Shortly thereafter, when the group had more German than Swiss members, it was renamed Milwaukee *Schützengesellschaft*.

The short-lived *Grüetli* and *Helvetia* societies were established after the war. The latter was organized in about 1867, waned, and was revived in 1872. That was also the year the stronger Milwaukee Swiss Club was established by A. Grüninger, Fred Bachmann, R. Fuellemann, George Egger, and Conrad Ulrich. They met at Senn's Hall on Third Street. Some members of the original clubs were already very ill or deceased. New leaders held top offices in the society: Otto Pupikofer, president; Edward Brodbeck, vice president; A. Wolfensperger, secretary; and Theodore Habhegger, treasurer. In 1886, they followed the lead of *Helvetia* and joined the North American *Grütlibund*, an umbrella organization that united Swiss societies around the country.

The *Schweizer Männerchor* was founded in 1879 by the Herrmann brothers, Otto Pupikofer, A. Grüninger, Christian Schneider, Edward Brodbeck, and others. They presented yearly concerts in the city. The tradition of the annual Swiss picnic on August 1 and the *Feiertag* celebration in November began around this time.

The new *Helvetia* club was organized in 1882 by some of the younger members of the *Männerchor*— Albert Dudly (from Flawyl, St. Gallen), Gustav Schäfli, Jakob Braunwalder, Alfred Bickel, and Edward Weber. Officers of *Helvetia* in 1886 were Albert Sonderegger, Fritz Habhegger, and Alfred Bickel. The membership focused on singing, literature, the arts, and contributing money to the opera and various libraries. Milwaukee Swiss participated in a large folk festival, *Schweizer-Volksfest*, in July 1885.

In June 1886, the North American Singing Festival (*Bundes-Sängerfest*) held in Milwaukee united the Milwaukee Swiss Club, singing society, and members of the Swiss community. Another gathering of the Milwaukee clubs and Swiss from Illinois took place at the south-side Turner Hall in September 1888.

The modern Swiss Gymnastic Society (*Schweizer Turnverein*) was formed by gymnasts who met at Joe Rotz's place on the corner of Fifth and Wright Streets on June 19, 1904. The *Vorwärts* Turn Hall on Third and Reservoir Streets was their new site. The first *Schauturen* (gymnastic exhibition) was held in June 1905, and the first ladies class was formed in November. The name of the organization was changed to *Schweizer Turnverein Helvetia* of Milwaukee, Wisconsin, in 1906. A year later, they became a member society of the Swiss-American *Turnerbund* (currently the Swiss-American Gymnastic Association).

The Swiss Ladies Society (*Schweizer Frauen Verein*) of Milwaukee, Wisconsin, was founded by 13 women at Christina Leuenberger's home in 1904. The group still meets monthly, and each spring they have an anniversary luncheon and sponsor a summer bus trip. Their mission is to create friendship and harmony among members, to be charitable, and provide assistance when needed. Membership is still open to ladies over 18 who are either Swiss, descended from Swiss, or married to a Swiss.

More recently, Swiss are still writing their own story in Milwaukee. The 31st Swiss American Singing Festival, the first since 1947, was held in Milwaukee in June 1985. William Stamm, Milwaukee's fire chief, was master of ceremonies. Joseph Gamma was food chairman of the event. It was attended by the Swiss ambassador, consul general, the Edmonton (Alberta, Canada) Swiss Men's Choir, and the *Handharmonika Orchester* from Kloten (Zürich). Mixed choral and yodeling groups from the Upper Midwest and Canada, all members of the North American Singing Alliance, participated. The alliance works "to foster and elevate Swiss national folk songs and yodel songs."

The Swiss were honored as the featured group at the 38th annual Holiday Folk Fair in 1981, increasing their visibility as a vibrant ethnic group in Milwaukee. In 1986, the International Institute of Wisconsin proclaimed March as Swiss Nationality Month. At the 1993 Holiday Folk Fair, the Swiss were recognized for their impressive exhibits and received an award for best artistic interpretation of their culture. The Swiss were still a part of the Holiday Folk Fair scene in 2009. Four Swiss societies are still serving the four county area. They are the Swiss Ladies Society, Swiss Singing Society, Swiss Turners, and the Swiss-American Fraternal Society.

One

CASTING OFF FROM DISTANT SHORES

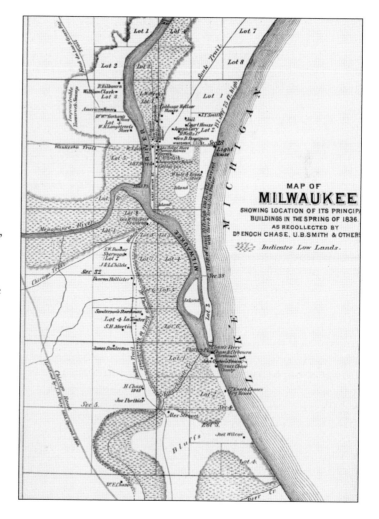

FIRST SWISS RESIDENT OF MILWAUKEE. George Wild, a carpenter, was born in Canton St. Gallen, in 1803. He sailed from Le Havre, France, aboard the ship *France* and landed in New York on July 3, 1835. After a stop in Detroit, he settled on a farm in Milwaukee two years later. This early view of Milwaukee illustrates the location of settlements when Wild arrived in the spring of 1837. By the time he died in 1860, a considerable number of Swiss had settled in the city. (Author's collection.)

MAP OF
MILWAUKEE
SHOWING LOCATION OF ITS PRINCIPA
BUILDINGS IN THE SPRING OF 1836,
AS RECOLLECTED BY
Dᴿ ENOCH CHASE, U.B.SMITH & OTHER
Indicates Low Lands.

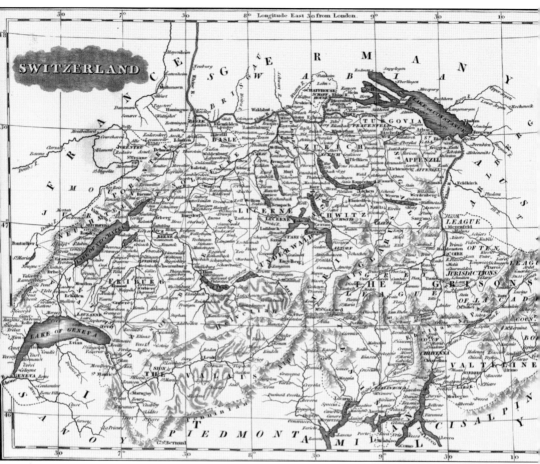

IMMIGRANT ORIGINS. Immigrants to Milwaukee came from all over Switzerland, but most hailed from German-speaking cantons. Because of this, they were often indistinguishable from their German neighbors—a particular problem for Milwaukee historians. Eminent Swiss scholar Dr. Leo Schelbert wrote in the *Harvard Encyclopedia of American Ethnic Groups*, "Because the Swiss are frequently taken for Germans, Dutch, French, or Italians, depending on the language or dialect they speak, they have remained largely invisible and numerically underestimated as a distinct group in the United States." Only a small number of Milwaukee's Swiss, with surnames like Mottet, Diacon, and Fasola, were from the French-speaking areas. Later a few came from Ticino (also Tessin), an Italian-speaking canton. One Italian-Swiss, Dominic Baroni, and his wife, Magdalena, were saloon keepers in Milwaukee's Third Ward. He was born in May 1849 and came to New York in August 1873. Other Ticinese in the city at one time were George Cerletti (born 1844, immigrated September 1857) and his wife, Margaretha; Giovanni Greppi (born 1846, immigrated 1891); Carlo and Pietro Galli; and Anthony Galloti. (Author's collection.)

HEIMATORTEN—PLACES OF RESIDENCE. During the 18th and early 19th centuries, Swiss immigrants to North America came primarily from Cantons Schaffhausen, Zürich, Bern, and Basel. They were destined mainly for Pennsylvania and Ohio. By the time the Wisconsin territory opened up in the 1830s and Milwaukee was incorporated as a city, it was settled by small waves of Swiss. Although they weren't always actively engaged in efforts to promote their culture, ties with their homeland were never completely severed. They maintained legal and emotional ties with their *Heimatorten* via citizenship rights, which were usually inherited from their forefathers. Some immigrants returned to Switzerland when they were able to afford it. A few of the more well-to-do citizens sponsored young men and women from their home communes to come to Milwaukee and provided jobs for them in their homes and businesses. Snapshots of the idyllic towns of Stein am Rhein in Canton Schaffhausen (above) and Meiringen in the Bernese Oberland (below) are typical of the home villages. (Author's collection.)

Der schweizerische

Auswanderer
nach Amerika,

oder:

Meine Erfahrungen in jenem Lande.

Niedergeschrieben

für diejenigen meiner Landsleute, welche auf die
sicherste und wohlfeilste Weise die Reise aus der
Schweiz nach Amerika machen und sich dort
auf die sicherste und wohlfeilste Art
niederlassen wollen,

von

Johann Hänggi, Sohn.

Nebst einer Karte der Vereinigten Staaten.

Preis 1 Fr. n. W.

Solothurn.
Druckerei von Fr. X. Zepfel.

1852.

ADVICE TO IMMIGRANTS. Johann Hänggi sailed from Nunningen, Solothurn, to America in 1833 with his younger brother Jakob. Jakob eventually settled in Waukesha, Wisconsin, but Johann returned to Switzerland. Later he wrote a popular travel guide titled *The Swiss Emigrant to America, or: My Experiences in that Country; Written Down for Those of My Compatriots, Who Want to Make the Journey from Switzerland in the Safest and Cheapest Way to America.* (Courtesy of the Universitätsbibliothek Basel.)

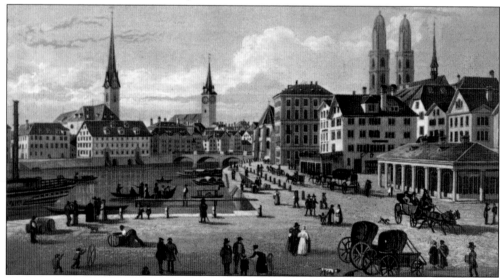

SHIP LANDING, ZÜRICH, 1840. Swiss en route to North America gathered their belongings, left their hometowns, and congregated in large cities like Basel and Zürich. They boarded covered river vessels, often small and cramped, at the docks and made the journey to busy Atlantic ports in France, Holland, Germany, and Belgium via the Rhine River. Many of the Swiss who settled in Milwaukee started their journeys from Zürich. (Author's collection.)

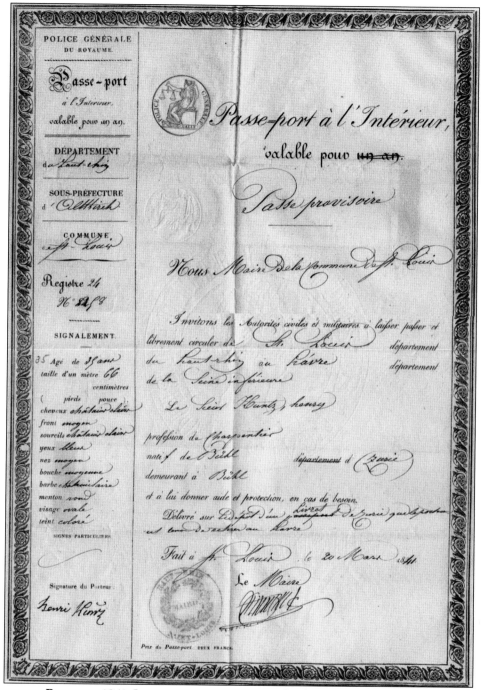

INTERNAL PASSPORT, 1841. Immigrants were not required to have a passport to enter the United States, but having one usually ensured the bearer safe passage through foreign lands as they made their way to ports. Immigrants sometimes were accosted by bandits or conscripted by foreign governments. After 1852, emigrants were encouraged to use the faster (and safer) railway connecting Basel to Le Havre via Strasbourg and Paris. (Courtesy of Scott R. Sieckman and Matthias Kastell.)

Louis Ambroise Garneray

LE HAVRE. Havre de Grace (its German name) is a seaport in northwest France, part of the *Departement of Seine-Infrieure*. Le Havre played a major role in Swiss emigration and was, for many, the final point of departure from Europe. By the mid-19th century, thousands of hopeful emigrants poured into the town from southern German states and Switzerland, in particular. The *Avant* port and the quays of its three principal basins were beehives of activity. The largest was the *Bassin de la Barre*. The *Bassin du Commerce* and *Bassin du Roi* were smaller. The first two,

Panorama du Havre de Grâce, pris de la jetée du Sud - Est

completed in 1820, could accommodate about 200 vessels by the 1840s. Ships from all over the world could be seen docking there. The trip from Le Havre to New York could take around 35 to 38 days and 55 to 60 days to New Orleans. Everything in Le Havre was said to revolve around the quays, commerce, and eventually, the emigrants. If emigrants arrived and the weather was bad or their ship had not arrived yet, they might have spent time in one of the inns of Le Havre, further depleting their coffers. (Author's collection.)

DEPARTURE. This is a view of the town and port from the quay *de la Floride*. During the 1840s, ships from the United States laden with cargoes of cotton or tobacco were unloaded, cleaned, and readied for their return. Passengers (mainly immigrants) replaced the cargo in the steerage deck. By 1847, Le Havre was connected by rail to the interior, and the first steamboats began their Le Havre-New York service the same year. (Author's collection.)

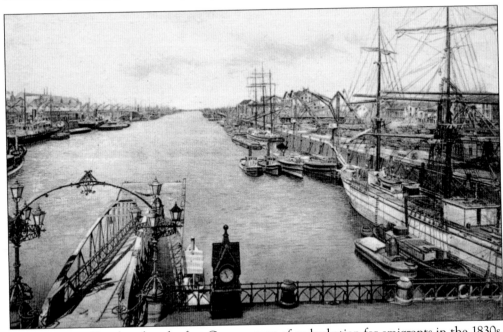

BREMERHAVEN. Developed as the first German port of embarkation for emigrants in the 1830s, Bremerhaven was the port of call for ships transporting a small percentage of the Swiss passengers bound for North America. A decade later, emigration trade became an important part of Bremen's economy. Features of Bremerhaven's toll-free harbor, *Freihafen*, are seen in this photograph. Mostly smaller ships, combining freight and passenger cargoes, used these docks. (Courtesy of Paul Makousky.)

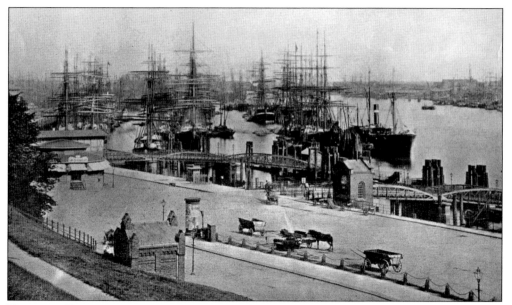

HAMBURG WAREHOUSES AND DOCKS, 1892. Almost 20,000 Swiss left Europe from the German port of Hamburg. They were headed for destinations in North America, South America, Africa, and Australia from the middle of the 19th century until the beginning of World War I. In the 1920s, when the economic downturn affected much of Switzerland and trans-Atlantic traffic resumed, Swiss continued to emigrate, but their numbers never exceeded those of the previous century. (Author's collection.)

CASTLE GARDEN, AUGUST 15, 1868. This early immigrant landing depot and labor exchange, located on the tip of Manhattan, served as the chief point of entry into the United States (port of New York) from 1855 to 1890. The State of New York was responsible for processing arrivals, recording their numbers, and providing them currency and a place to meet relatives. (Courtesy of the Library of Congress, LC-USZ62-100020.)

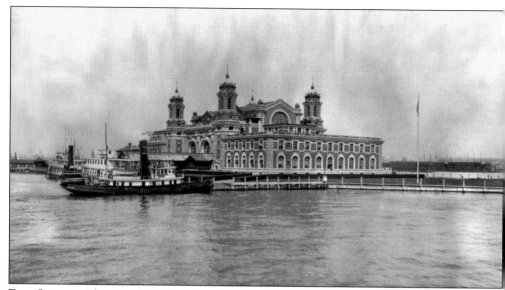

ELLIS ISLAND. After Castle Garden closed on April 18, 1890, the federal government established a temporary processing center for immigrants at the Old Barge Office, near the U.S. Customs House in Manhattan. Thereafter the federal government assumed jurisdiction over the port of New York and opened Ellis Island on January 1, 1892. The center processed almost 70,000 Swiss immigrants before it ceased operations in 1954. Other U.S. ports, like New Orleans and Baltimore, examined thousands as well. (Courtesy of the Library of Congress, LC-USZ62-40101.)

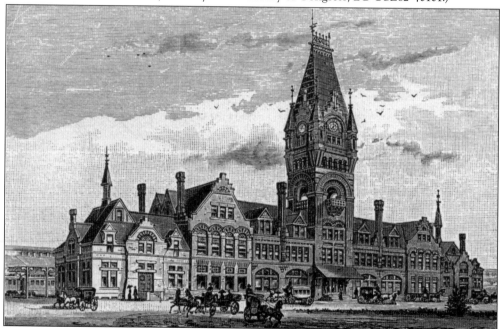

RAILWAY DEPOT (1886–1968). When this sketch was done, the newly built redbrick Chicago, Milwaukee, and St. Paul Railway depot in Milwaukee was a jewel of period railroad architecture. It was considerably larger and more ornate than the city's first station. By the middle of the 19th century, new immigrants were making their way to the city by rail. Previously, water or overland routes were favored. (Author's collection.)

ONBOARD THE COLUMBUS. Young, adventurous Swiss kept coming well into the 20th century. This group of hopeful emigrants includes Clara Elsaesser (third row, third woman from the right). Born in Germany to a Swiss mother, Clara moved to St. Gallen when she was a young girl. She married her sweetheart, Jacob Buchmann, a Milwaukee-Swiss meat cutter, at the end of her journey in April 1929. (Courtesy of Emmely Gideon-Buchmann.)

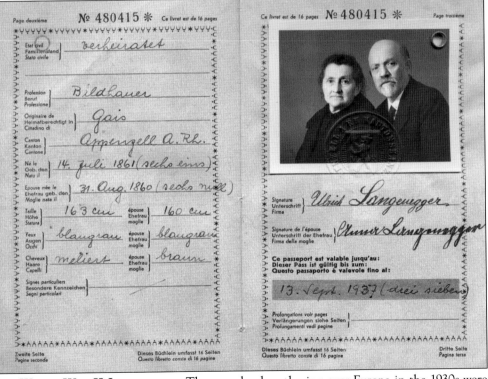

PRE–WORLD WAR II IMMIGRATION. The war clouds gathering over Europe in the 1930s were worrisome to many Swiss who made the decision to leave. Ulrich Langenegger Sr. (1861–1943), a sculptor, from Gais, Appenzell Ausser-Rhoden, immigrated with his Münich-born wife, Anna Maier. She died in 1934, shortly after their arrival in Milwaukee. The couple came to the city to join their son Albert Ulrich, who immigrated 10 years before, and his family. (Courtesy of Bert Langenegger.)

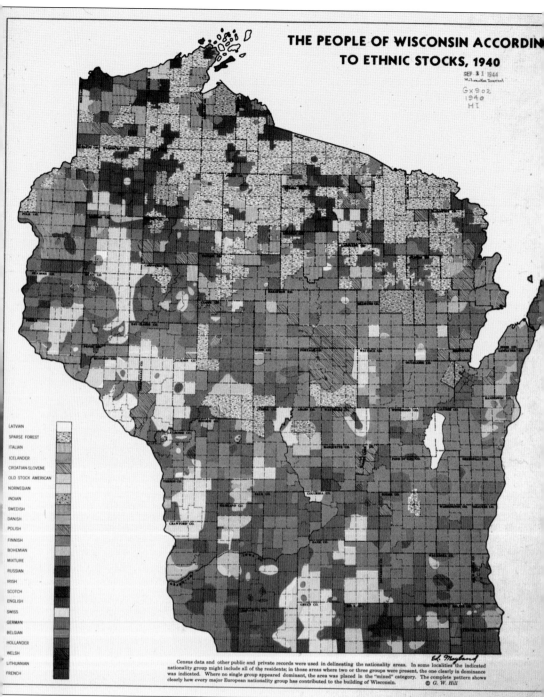

THE PEOPLE OF WISCONSIN ACCORDING TO ETHNIC STOCKS, 1940

LATVIAN
SPARSE FOREST
ITALIAN
ICELANDER
CROATIAN-SLOVENE
OLD STOCK AMERICAN
NORWEGIAN
INDIAN
SWEDISH
DANISH
POLISH
FINNISH
BOHEMIAN
MIXTURE
RUSSIAN
IRISH
SCOTCH
ENGLISH
SWISS
GERMAN
BELGIAN
HOLLANDER
WELSH
LITHUANIAN
FRENCH

Census data and other public and private records were used in delineating the nationality areas. In some localities the indicated nationality group might include all of the residents; in those areas where two or three groups were present, the one clearly in dominance was indicated. Where no single group appeared dominant, the area was placed in the "mixed" category. The complete pattern shows clearly how every major European nationality group has contributed to the building of Wisconsin. © G. W. Hill

SWISS IN WISCONSIN. This map and its legend make it easy to track basic patterns of distribution and numbers of Swiss in Wisconsin in 1940. Milwaukee, Buffalo, Fond du Lac, Green, Sauk, La Crosse, and Winnebago Counties all had sizable Swiss settlements. Swiss were dispersed widely throughout the state, particularly in rural areas. Their main urban concentration is in the Milwaukee area. (Courtesy of the Wisconsin Historical Society.)

20

Two

TRANSFORMING

MILWAUKEE

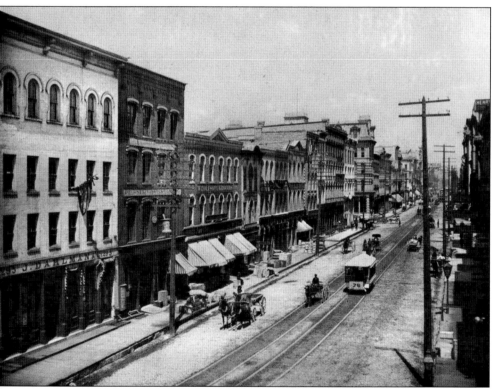

MILWAUKEE'S SWISS. The Swiss who came to Milwaukee have never been properly acknowledged or enumerated. In 1870, there were 447 Swiss in Milwaukee, which grew to 764 in 1890, then 1,122 in 1920, and 1,414 in 1930, according to the U.S. federal censuses. These figures undoubtedly fall woefully short. Whatever the reality, the Swiss proved to be ingenious, inventive, creative, and resourceful, becoming accomplished businessmen, tradesmen, and professionals. In their leisure time, the immigrants tended to congregate in Swiss-owned inns that reminded them of the homeland—many in the area shown in this photograph. (Author's collection.)

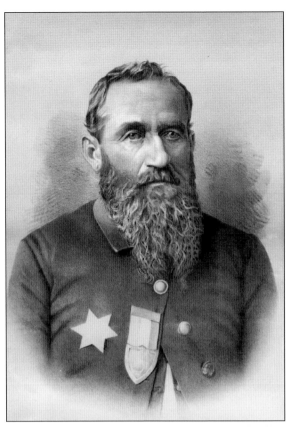

ONE OF MILWAUKEE'S FIRST POLICEMEN. Peter Dusold, a Bavarian of Swiss parentage, came to Milwaukee in 1845. After a brief stint in the Mexican War, he returned to Milwaukee, joined the police force in 1856, and served for over a quarter century. He married a Swiss woman, Rosalie Castee, and they had eight children. Legend says he carried his baby daughter in his arms as he walked the beat. (Courtesy of the Milwaukee County Historical Society.)

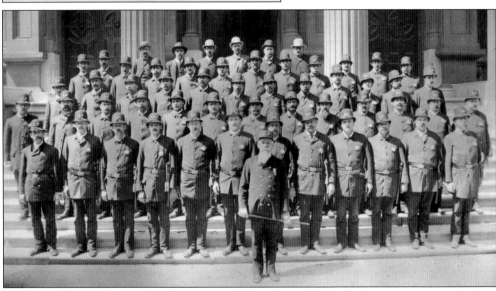

ROUNDSMAN. Nicholas Luchsinger (fourth row, sixth from right) was born in Switzerland about 1831 and died in Milwaukee in 1909. He joined the Milwaukee Police Department, became a roundsman in 1888, and was appointed sergeant in 1890. Roundsmen marched out with their men in the evening and made sure each of them was properly placed on his assigned beat until morning. (Courtesy of the Milwaukee Police Historical Society.)

The Kuhns. Henry Kuhn (1829–1898) was born in Oberstrass, Zürich, and immigrated in 1852. He married Salome Wellauer in Milwaukee on March 6, 1856. Salome was born in 1833 in Wagenhausen, Thurgau, and died in April 1902. Although the couple had four young children, Henry was drafted into service during the Civil War in November 1863, but he hired a substitute to serve in his place. The family removed to Oshkosh, Wisconsin, in 1880. (Courtesy of William E. Kuhn.)

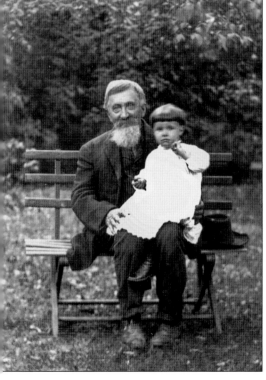

The Kuenzlis. Grandpa Rudolf Kuenzli (1836–1916) poses with his grandchild. He and his family immigrated from Muhen, Aargau, on April 25, 1854. His son Samuel (1833–1887), longtime postmaster on Milwaukee's south side, started his own grocery and wholesale liquor business in 1859. Rudolf's grandson Edwin O. (1871–1948), was a prominent Milwaukee architect who designed and built Wauwatosa East High School, the West Allis Library, and the First Congregational Church in Wauwatosa. (Courtesy of Justin James.)

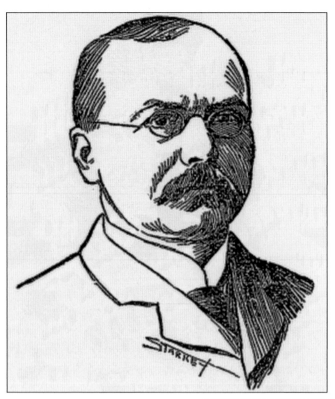

HELVETIA SOCIETY PRESIDENT. Otto Pupikofer, the son of Johannes and Sophia (Scherrer) Pupikofer, was born in March 1845 in Canton Thurgau. He came to New York in August 1868, moved to Milwaukee, and joined the Swiss Club in 1878. Pupikofer was an eminent mechanical engineer at E. Allis and Company. He and his wife, Louisa, raised three children—Sophia, Louisa, and Otto Jr. He died in Milwaukee in 1920. (Author's collection.)

MILLINER. John Lorenz Locher was the owner of Blumenfeld Locher Company, a wholesale millinery establishment, at 755 North Broadway Street. Locher was born in Milwaukee on September 7, 1862. His father, Joseph Henry (a wagon builder who came to the city from Switzerland in 1848), conducted business under the name of Locher and Fehr. His maternal grandfather, David Stocker, also Swiss, farmed in North Greenfield. (Courtesy of the Historic Photographic Collection/ Milwaukee Public Library.)

BRILLIANT DOCTOR. Dr. Nicholas Senn (1844–1908), one of the most renowned surgeons in the country, was born in Buchs, St. Gallen. He came to Fond du Lac County with his parents in 1851. Senn married Amelia Muehlhauser in 1869, and they moved to Milwaukee. His rise from county physician in 1875, to lieutenant colonel, and chief surgeon of U.S. volunteers, and chief of operating staff with the field army was meteoric. (Courtesy of the Milwaukee County Historical Society.)

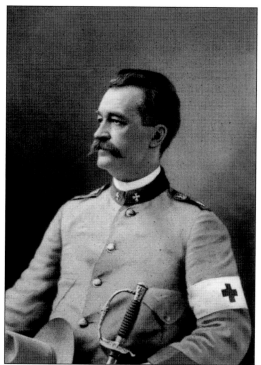

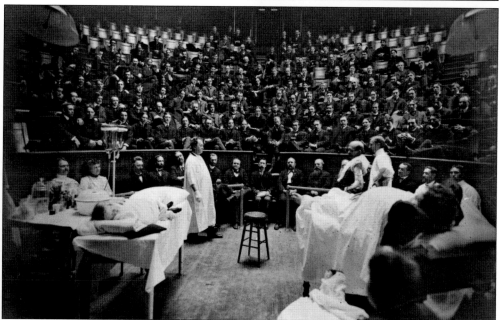

OPERATING THEATER, RUSH MEDICAL COLLEGE. Dr. Senn enjoyed universal respect as a "great master of abdominal surgery." His friend and companion Dr. D. R. Brower wrote that Senn "was probably the most traveled medical man in this or any other country." He called him "the world's greatest surgeon." Dr. Senn founded the Association of Military Surgeons of the United States, was the American Medical Association's 49th president, and surgeon general of the Wisconsin National Guard. (Courtesy of the Wisconsin Historical Society.)

SENN BLOCK. Reportedly Dr. Senn declined an invitation from the czar of Russia to visit the Kremlin but once visited the leper colony on Molokai. When he wasn't traveling, he maintained an office and laboratory in this sturdy Italianate, cream city brick building located in the "Nicholas Senn block" at 300 West Juneau Avenue. Constructed in 1876, the building still stands today. A historical marker was erected in 1997. (Photograph by Maralyn A. Wellauer-Lenius.)

FIRST HOLY ANGELS ACADEMY. Dr. Nicholas Senn's private residence at Twelfth and Cedar Streets (now Kilbourn Avenue) was purchased in 1892 by the Sisters of Charity of the Blessed Virgin Mary, who founded an all-girls school. They converted the first floor into a chapel and music and recitation rooms. Boys were accepted the first year only. The building was razed in 1926, and the school was relocated. (Courtesy of the Historic Photographic Collection/Milwaukee Public Library.)

DR. JOHN SCHWENDENER. Schwendener, Dr. Nicholas Senn's cousin, was born in St. Gallen on July 19, 1847, and immigrated in 1848. He grew up in Wayne, Wisconsin, graduated from the Chicago Medical School, and moved to Milwaukee in 1885. Schwendener was a devoted and energetic physician until his death from nephritis on August 30, 1914. He was survived by his wife, Lena, and seven children, one of whom was a dentist in Milwaukee. (Author's collection.)

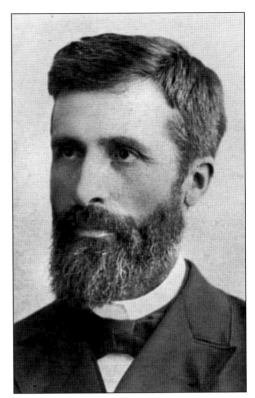

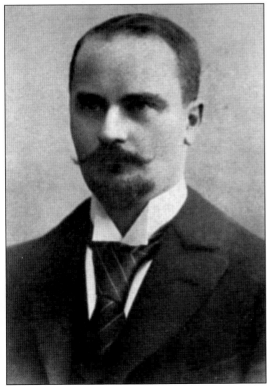

OPHTHALMOLOGIST. Paul Gygax is described in *The Medical History of Milwaukee 1834–1914* as "a most agreeable personage to meet, a man of culture and the highest literary taste." Born in Langenthal, Bern, in August 1861, Gygax studied medicine in Bern, Tubingen, Strasbourg, Berlin, and Vienna. He came to Milwaukee in 1895. Four years later, he traveled to Münich to study bacteriology and died there suddenly on December 17, 1899. (Author's collection.)

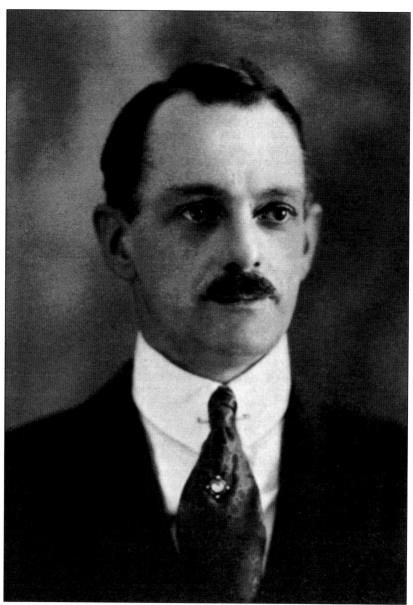

THE TESCHANS. Dr. Rudolph Carl Teschan was born in April 1852 in Reigoldswil, Basel-Land, and died February 1, 1921. He immigrated to New York in July 1875 and came to Milwaukee much later in 1888. A prominent physician and surgeon, Teschan received his training in Switzerland. He and fellow Swiss John Glaettli were on the organizing committee of the 1893 North American Turner Fest held in Milwaukee. In 1898, he passionately spoke out against the practice of forced child labor. Teschan lived in Milwaukee's Fifth Ward in 1900 with his wife, Lena (Gilbert), and their five children, Hulda, Rudolph, Gertrude, Walter, and Erhard. His son Walter F. Teschan (shown above) started his career at the Milwaukee Concrete Mixer Company after graduating from the University of Wisconsin with a degree in mechanical engineering. He later became president of the company in 1916. Walter, born in Winona, Minnesota, on September 22, 1883, was an accomplished violinist. He married Ernesta von Baumbach in April 1907, and they had three children. (Author's collection.)

MIL HARLOW OTT. President of William teinmeyer Company, once the largest ocery house in the state, Emil was orn in Monroe, Wisconsin, to John C. nd Catherine (Deggler) Ott. His father as educated at Zürich University and ft Switzerland in 1847. Emil began his reer as an errand boy and clerk with teinmeyers, eventually becoming a rtner in the firm. He married the boss's aughter, Ida Steinmeyer, in 1886, and ey had three sons. (Author's collection.)

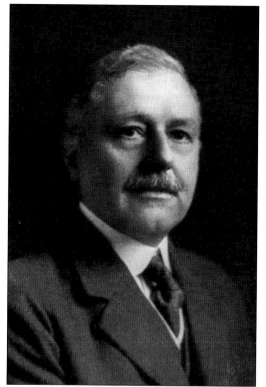

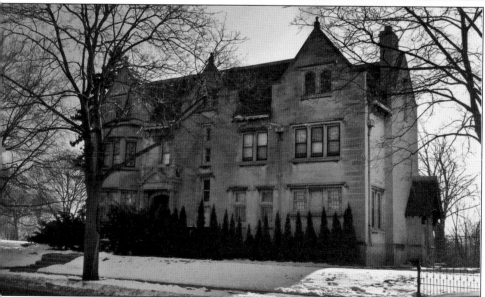

T RESIDENCE. Perched on a bluff overlooking Lake Michigan, this English Tudor mansion 2121 East Lafayette Place in Milwaukee was the home of Emil H. Ott. Designed by architect C. Clas and built in 1907, the home's exterior construction incorporates fine limestone sonry, copper gutters, and a red slate roof. The stunning interior had a carved marble English naissance staircase, oak paneling, wrought iron, and ornamental plaster. (Photograph by ralyn A. Wellauer-Lenius.)

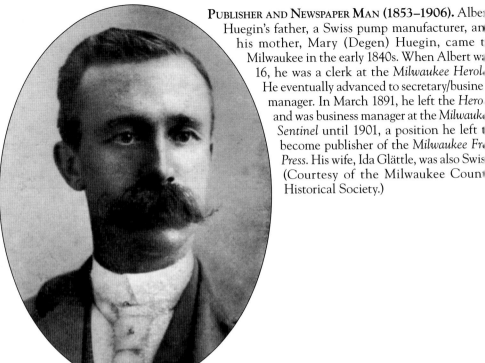

PUBLISHER AND NEWSPAPER MAN (1853–1906). Albert Huegin's father, a Swiss pump manufacturer, and his mother, Mary (Degen) Huegin, came to Milwaukee in the early 1840s. When Albert was 16, he was a clerk at the *Milwaukee Herold*. He eventually advanced to secretary/business manager. In March 1891, he left the *Herold* and was business manager at the *Milwaukee Sentinel* until 1901, a position he left to become publisher of the *Milwaukee Free Press*. His wife, Ida Glättle, was also Swiss. (Courtesy of the Milwaukee County Historical Society.)

GERMANIA BUILDING. This Milwaukee landmark, located at the intersection of West Water, Wells, and Second Streets in downtown Milwaukee, was the center of George Brumder's thriving local book publishing, printing, and binding business. He employed Swiss immigrants Otto Knuesti (born about 1842) and William J. Herrmann (a printer who came to Wisconsin in 1875). (Author's collection.)

CHARLES S. UTZ. Frederick Utz immigrated two years before his wife, Eliza (Ries) Utz, and their three children joined him in New York. They came to Milwaukee in 1856, where Frederick became a pattern maker. Frederick's son Charles (shown at right) was born in 1859. He worked for George Brumder in the printing trade at Germania for 23 years. Brumder helped Utz establish a company making printers' rollers. He later became president. (Author's collection.)

PROMINENT MILWAUKEE FINANCIER. Herman Fehr (shown at left) was born on February 27, 1865. His father, Jacob Fehr, a Zürich native, immigrated in October 1854. He settled in Milwaukee, where he married his Bernese wife, Katherine Stocker. Jacob was a blacksmith and wagon maker until his death in 1908 at the age of 80. Herman was chairman of the board of the National Bank of Commerce, alderman of the Second Ward (1890–1893), and was nominated as the Democratic candidate for mayor. (Author's collection.)

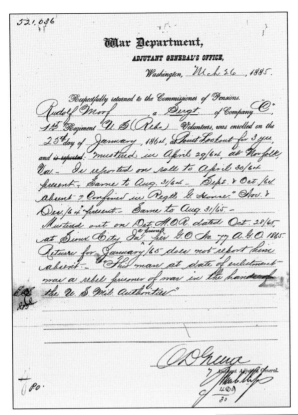

JOHNNIE REB AND BILLY YANK.
Rudolf Morf (1835–1902) was born
in Volketswil, Zürich. He entered
the port of Galveston, Texas, in
1854. He was a corporal (Company
G, 5th Louisiana Infantry) at the
beginning of the Civil War. In 1863,
after his capture at Rappahannock,
he joined the Union Army. Later he
was a saloon keeper in Milwaukee
and manufactured clothes wringers
at North 582 East Water Street.
He married Margaretha Götz in
May 1866. (Author's collection.)

ALBERT SPEICH. President of the
Speich Stove Repair Company
on West Water Street, Albert was
born to Joachim and Marianna
(Stocker) Speich on September
25, 1860. His father, a Swiss tailor,
came to Milwaukee in 1850, and
his mother came to the city with
her parents at an early age. In 1888,
Albert married Catherine Haffner,
and they had three children.
His second wife was Catherine
Wrasse. (Author's collection.)

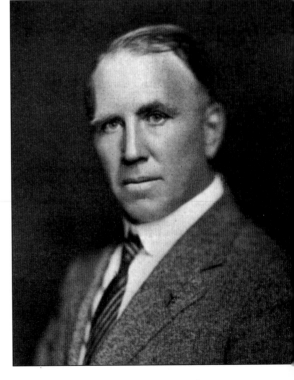

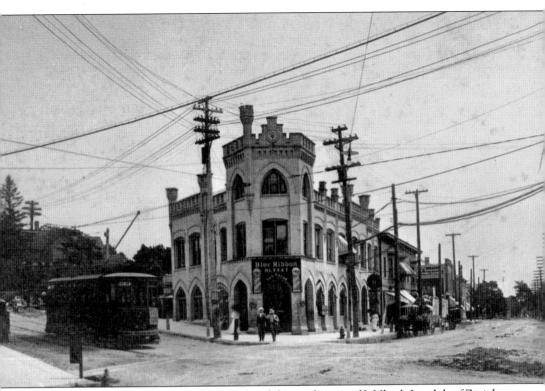

WAUWATOSA POST OFFICE, 1902. William H. Landolt was the son of J. Ulrich Landolt of Zürich, a bookbinder, and Louisa von Spiegel. Three-year-old William immigrated with his parents in 1847 and stayed a short time in New York City. They came to Wisconsin in 1848 and settled in Port Washington, where he received a public school education. Landolt enlisted in the Civil War in April 1861 and was a private in Company C of the 5th Regiment, Wisconsin Infantry. He returned to Milwaukee after having a leg amputated after he was severely wounded at the battle of Sailor's Creek in 1865. He went back to Port Washington, where he served as county treasurer for three terms. His wife, Betty, died in 1879. In 1890, he moved to Wauwatosa, working with the firm Bell and Norris until March 1899, when he was appointed postmaster. This image shows the Pabst Saloon, which was expanded to accommodate the Wauwatosa Post Office. (Courtesy of the Wauwatosa Historical Society.)

EARLY MILWAUKEE PHARMACIST. Alvin Joseph Loepfe was born in Canton St. Gallen in November 1870. He came to Milwaukee in July 1880 with his parents, cabinet maker John (d. 1895) and Catherine (Egger) Loepfe (d. 1922). Alvin managed the City Hall Pharmacy at the corner of East Water and Biddle Streets until he died in 1912. He was survived by his wife and two sons. The Edelweiss Café is the fifth establishment from the left-hand corner. (Courtesy of the Library of Congress, LC-D4-13177.)

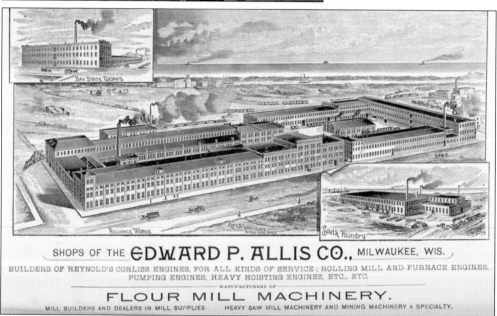

ALBERT SONDEREGGER. Sonderegger was a draughtsman and mechanical engineer. He and fellow countryman Otto Pupikofer worked at E. Allis and Company. Sonderegger was born in Switzerland in September 1855 and immigrated in November 1882. His Swiss wife, Caroline, was born in 1864 and immigrated in 1883. They had two sons, Hugo and Max. Albert was president of the *Helvetia Schweizer Verein* (*Helvetia* Society). (Author's collection.)

PUBLIC ACCOUNTANT. Adolf Hafner was president of the firm Adolf Hafner and Company—public accountants, production engineers, auditors, and taxation counselors—with offices in the Caswell block in downtown Milwaukee. Hafner was born in Milwaukee on March 6, 1889, to a Swiss father, Adolf Hafner Sr., and his Milwaukee-born wife, Louise Tyre. He was an active member of the Swiss Club and the south side *Turnerverein*. (Author's collection.)

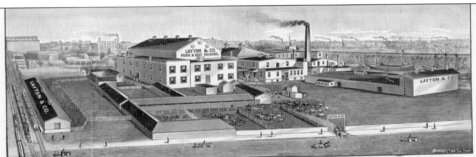

LAYTON & CO.,
PORK AND BEEF PACKERS,
AND CURERS OF
CHOICE SUGAR CURED HAMS, SHOULDERS,
Dried Beef and English Breakfast Bacon,
And Prime Pure Kettle Rendered Lard,
86 AND 88 WEST WATER STREET, - - - MILWAUKEE, WIS.

NOTICE { ALL OUR HOG PRODUCTS PASS A GOVERNMENT INSPECTION, AND NONE ARE PLACED ON THE MARKET WITHOUT OFFICIAL CERTIFICATE. DEALERS CAN GUARANTEE THEM.

LAYTON AND COMPANY. Adolf Hafner Sr. came to the United States in January 1882, when he was 24 years of age. He was employed by the Layton packing company as a weight master. When he died in 1916, the management closed the entire plant during the funeral hours. It was the first time such an honor was paid to an employee of the company. (Author's collection.)

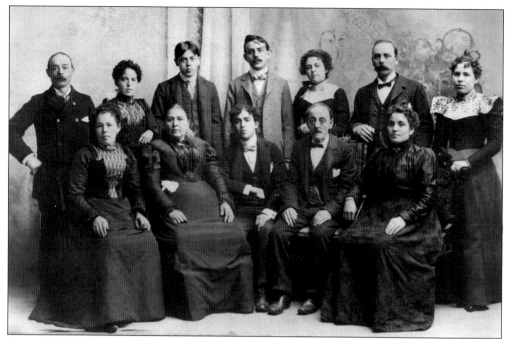

FELBER FAMILY, 1890. This photograph was taken shortly after the family's arrival in New York from Oberbipp, Bern, on the *Normande*. Pictured from left to right are (first row) Louisa Felber Maegli, Maria Haudenschild Felber (mother), John Felber, Johannes Felber (father), and Elizabeth Felber Buetschli; (second row) Gottfried Felber, Rose Felber Maegli, Albert Felber, Emil Felber Sr., Ida Felber Knudson, Robert Felber, and Marie Felber Leibundgut. (Courtesy of Robert J. Felber.)

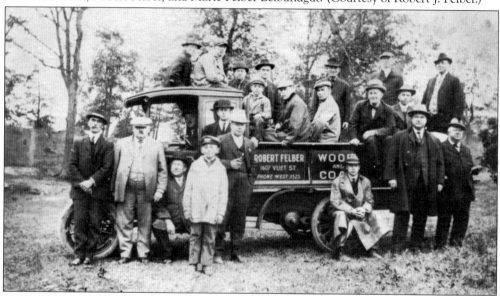

KEEPING MILWAUKEE WARM. Robert Felber founded his fuel company in 1903 and served as president until his retirement in 1937. He was president of the Swiss military band for 11 years and a member of the Swiss American Fraternal Society, Swiss Alliance, Swiss Turners, and *Schweizer Männerchor*. In this photograph, Armin Felber is seen in the back of the truck, Emil Felber Sr. is behind the wheel, and young Emil Felber sits in the cab. (Courtesy of Robert J. Felber.)

[CONTRIBUTION FROM THE NEWPORT CHEMICAL CORPORATION]

SEVERAL NEW 4'-SULFO-ORTHO-BENZOYLBENZOIC ACID DERIVATIVES AND THE CORRESPONDING ANTHRAQUINONE COMPOUNDS[1]

By Ivan Gubelmann, H. J. Weiland and O. Stallmann

Received October 30, 1930 Published March 6, 1931

Several new 4'-sulfo-o benzoylbenzoic acid derivatives and the corresponding anthraquinone compounds are described. They are, 4'-sulfo-2-benzoyl-5-nitrobenzoic acid, 2-nitroanthraquinone-7-sulfonic acid, 2-nitro-7-chloroanthraquinone, 2-amino-7-chloroanthraquinone, 4'-sulfo-2-benzoyl-5-aminobenzoic acid, 2-aminoanthraquinone-7-sulfonic acid, 2,7-diaminoanthraquinone.

In the synthesis of anthraquinone derivatives from 4'-sulfo-o-benzoylbenzoic acid, a very interesting series of new compounds has been studied.

When 4'-sulfo-o-benzoylbenzoic acid is nitrated the nitro group enters the benzoic acid ring, not the sulfo benzene ring, as expected. The main product formed is 4'-sulfo-2-benzoyl-5-nitrobenzoic acid.

4'-Sulfo-2-benzoyl-5-nitrobenzoic acid is soluble in concentrated sulfuric acid and on heating the solution the ring closes to form 2-nitroanthraquinone-7-sulfonic acid.

By treating 2-nitroanthraquinone-7-sulfonic acid with sodium chlorate

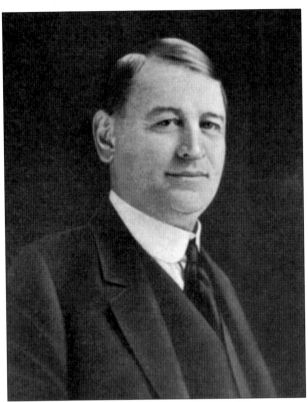

WIRE GRASS RUGS. Emil Herman Steiger's father, Jacob, was from Grindelwald, Bern. He settled on a farm in Waupaca County in 1858 and made cheese. At age 18, Emil Steiger (shown at left) pioneered the manufacture of wire grass rugs. He developed special machinery for weaving grass rugs in 1900 and revolutionized trade in modern floor coverings in Europe, Panama, and South America. Emil was president of Detox Grass Rug Company, which maintained offices in Milwaukee and salesrooms in New York. (Author's collection.)

COWBOYS. Gottfried Jacob Dettwiler (standing), his brother-in-law Ed Voeglin (seated), and sister Maria left Switzerland on October 14, 1890. Gottfried was born in Bretzwil, Basel, on November 11, 1870. He was a wild horse and cattle dealer employed by Feebruns in Milwaukee. Gottfried, also a talented singer and yodeler, often performed with his brother Dan and Maria. Jacob was a member of the Swiss Singing Society. (Courtesy of Robert Uhlig.)

Ostern 1918

SWISS APPRENTICESHIP. Jacob Buchmann, one of 13 children, was born on January 2, 1900, in Canton Zürich, near Wald. After receiving extensive training in European meat-cutting skills, he immigrated in 1924. His fiancé, Clara Elsaesser, joined him in Milwaukee in 1929. She became his helpmate in business, and they had one daughter, Emmely Claire. Clara was active in the Swiss Ladies Society for 63 years. (Courtesy of Emmely Gideon-Buchmann.)

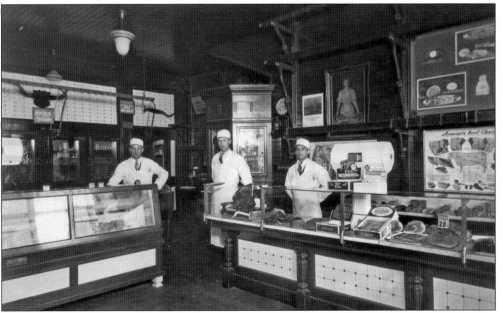

BUCHMANN MEATS. This family-owned wholesale/retail meat shop at 2043 West Wells Street, in business for over 46 years, attracted customers from Chicago and Minneapolis. The Pfister Hotel and Karl Ratzsch's and Mader's German restaurants were among his loyal Milwaukee patrons. Jacob (Jack) Buchmann operated several giant grills at the annual August 1 Swiss picnics, where roasted veal bratwurst was the favored treat. Jacob was a member of the Swiss Singing Society. (Courtesy of Emmely Gideon-Buchmann.)

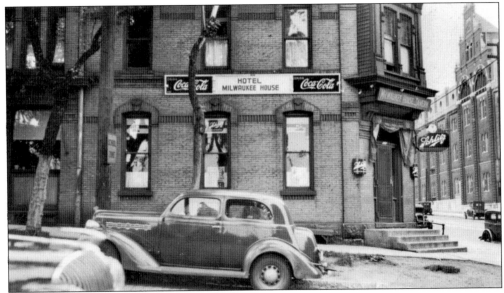

Milwaukee House. This boardinghouse and tavern was located at 521 North Third Street in downtown Milwaukee near the historic Turner Hall and Schlitz Brewing Company. It was owned and operated for many years by Adolph and Marie Luethy. Marie was born in Schöftland, Aargau, in 1880. Adolph was born in Canton Bern in 1871 and immigrated in 1892. It was one of the *Schweizer Männerchor's* favorite meeting places. (Courtesy of Fred Roethlisberger.)

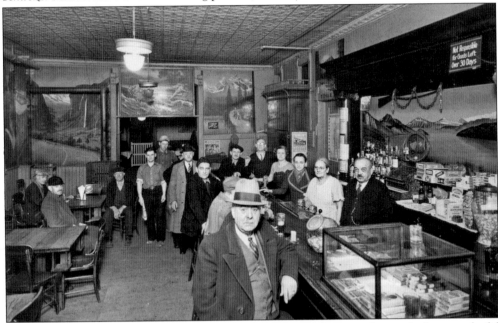

Almost Like Home. The Milwaukee House was undeniably Swiss on the inside. Large, colorful murals of the mountains, lakes, and valleys of Switzerland adorned the walls. They must have certainly reminded Swiss patrons of their homeland. Adolph, Marie, and their daughter Emma Luethy are seen behind the counter. Emma, born in 1915, married Ferd Roethlisberger. They were active in the Swiss Turners and Swiss Fraternal Society until their deaths in 1984 and 1994. (Courtesy of Fred Roethlisberger.)

Three

RELIGIOUS LEADERS IN THE COMMUNITY

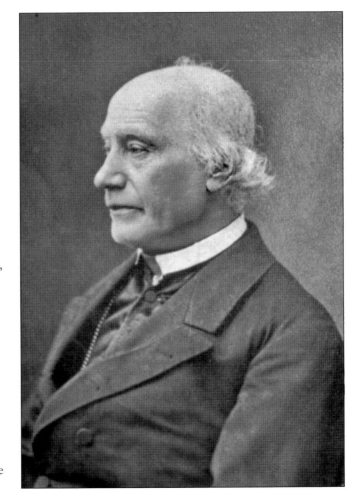

PATRIARCH OF THE NORTHWEST. John Martin Henni was instrumental in establishing Marquette University and founding St. Francis Seminary. On March 19, 1844, Henni was consecrated the first bishop of the newly created Diocese of Milwaukee. He personally supervised the construction of two Milwaukee landmarks, St. John's Cathedral on North Jackson Street and St. Mary's church on Broadway Street. Both parishes served many of Milwaukee's Swiss Catholics. After Milwaukee was designated an archiepiscopal see in 1875, he was appointed its first archbishop. Henni died in Milwaukee on September 7, 1881, and is entombed at St. John's Cathedral. (Courtesy of the Archdiocese of Milwaukee Archives.)

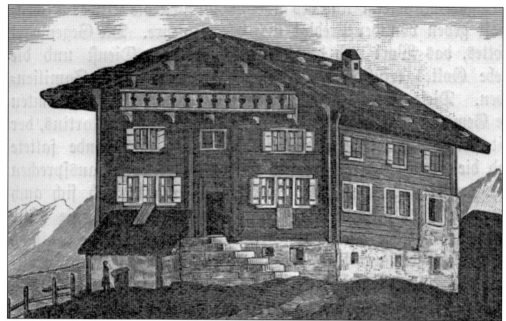

GEBURTSHAUS MISANENGA. The Most Reverend John Martin Henni was born in this chalet in the parish of Obersaxen, Graubünden, on June 13, 1805. His parents were Johann Georg Henni and Maria Ursula Henni. The building was constructed in 1793 by Virgil Joseph Valier, Hans Peter Riedi, and Johann Martin Henni (the archbishop's maternal grandfather). Several Swiss immigrants in Milwaukee came from the same area as the archbishop. (Author's collection.)

DER WAHRHEITSFREUND. John M. Henni founded the Catholic weekly, *Der Wahrheitsfreund* (Friend of Truth), and published the first issue on July 20, 1837. For some time, it was the only German Catholic newspaper in the United States. The paper was designed to provide immigrants with practical advice on life in the new world (mainly Ohio). Content emphasized keeping the faith alive, and it provided a guiding spirit to readers. (Author's collection.)

OLD ST. MARY'S CATHOLIC CHURCH.
Milwaukee's first German-speaking
Roman Catholic parish provided a
spiritual haven for many Swiss families.
The church was designed by architect
Victor Schulte and built on the southeast
corner of North Broadway Street and
East Kilbourn Avenue between 1846 and
1847. Bishop Henni laid the cornerstone
in April 1846. (Courtesy of the Library of
Congress, HABS WIS, 40-MILWA, 9-1.)

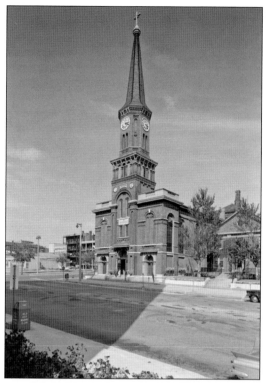

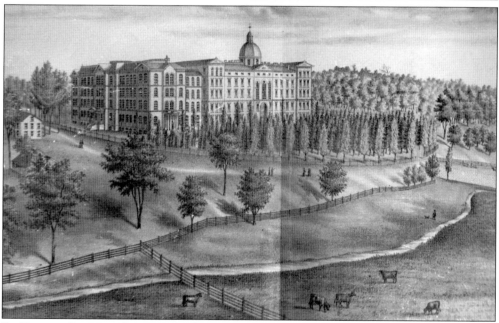

ST. FRANCIS CATHOLIC SEMINARY. Bishop Henni laid the seminary's cornerstone on July 15, 1855, in a solemn ceremony attended by many Catholics. The building was finished on January 29, 1856, the feast day of St. Francis of Sales, patron saint and namesake of the institution. At the start, there were 25 students and four professors. Bishop Henni ordained the first 14 priests there in December 1859. (Courtesy of the Archdiocese of Milwaukee Archives.)

PROFESSOR OF MUSIC. John Singenberger was called to St. Francis Seminary from his position as professor of music in Chur (Graubünden) in March 1873. He was born in Kirchberg, St. Gallen, on May 25, 1848, the son of Joseph and Barbara (Baumberger) Singenberger. He married Caroline Baltzer of Chur at St. Francis on August 15, 1873, and was later elected president of the American Cecelian Society of the United States. (Courtesy of the Archdiocese of Milwaukee Archives.)

WISCONSIN'S OLDEST REMAINING CATHOLIC CHURCH, 1899. Martin Kundig was the first pastor of old St. Peter's Catholic Church. The small wooden structure was erected on the northwest corner of East State and North Jackson Streets from 1839 to 1842 on lots donated by Solomon Juneau. From 1844 to 1853, it served as Milwaukee's Roman Catholic cathedral, the first in the state. (Courtesy of the Library of Congress, HABS WIS, 40-MILWA, 2.)

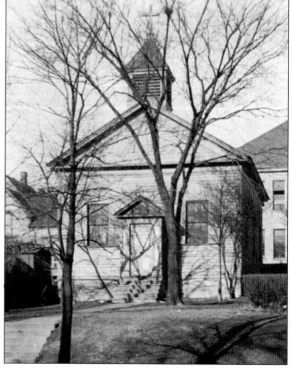

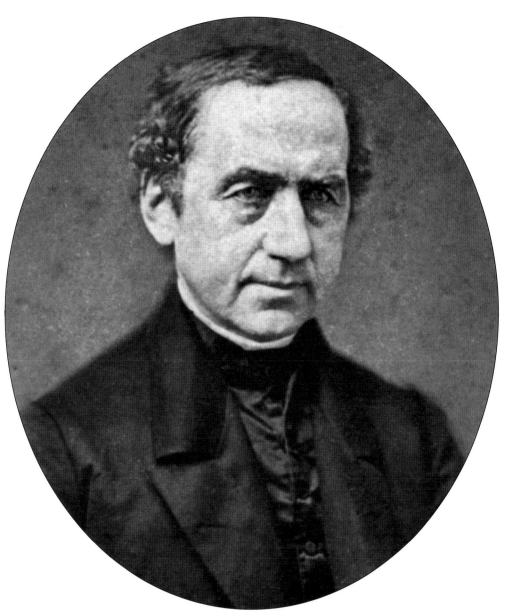

REVEREND FATHER MARTIN KUNDIG. Kundig was born in Steinen, Schwyz, in 1805, and he and John Martin Henni, both educated in Lucerne and Rome, were friends in their student days. In 1828, they traveled to the United States together. In 1841, Rev. Martin Kundig accompanied the first bishop, the Right Reverend P. LeFevre of Detroit on a visit to Milwaukee, and he stayed. LeFevre referred to him as "one of [his] zealous priests." During the 1840s, he rode out on horseback to various Catholic settlements in the area, offering mass once a month under crude conditions. He founded St. Martin's parish, later renamed St. Francis de Sales, on the edge of Lake Geneva in 1844. Kundig organized the first Catholic parish in Erin (Waukesha County). He became Henni's vicar-general, and his name is linked with the early history and growth of the diocese. He died on March 6, 1879, and was buried in Calvary Cemetery. Two sisters, Frances Kundig, a schoolteacher, and another whose name is unknown, were buried in a small cemetery near the St. Francis Seminary. (Courtesy of the Archdiocese of Milwaukee Archives.)

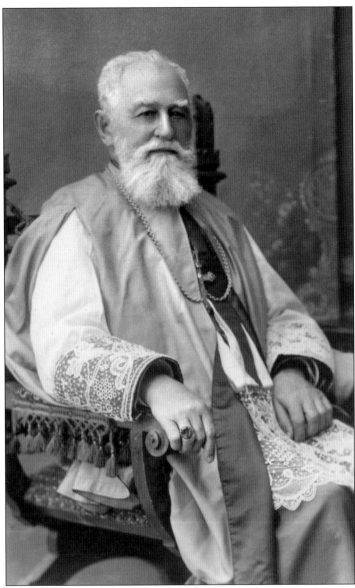

THE MOST REVEREND SEBASTIAN G. MESSMER. Reverend Messmer, D.D., D.C.L, was born at *Zum Rietli* in Goldach, St. Gallen, on August 29, 1847, one of five children. He studied theology and philosophy at the University of Innsbruck and was ordained there in July 1871. He immigrated to the United States the same year and was immediately appointed professor at Seton College in Newark. In 1891, Reverend Messmer was consecrated bishop of Green Bay (Wisconsin) and became archbishop in November 1903. He distinguished himself as a prolific contributor to the field of Catholic literature and is linked with various religious movements in the country. During his tenure in Milwaukee, he reduced the size of the diocese, modernized St. Francis Seminary, and reorganized overburdened charitable institutions to ensure greater efficiency. Messmer High School was named after him. The archbishop died suddenly on August 4, 1930, while vacationing in his boyhood home, which he liked to visit yearly. He was buried there according to his wishes. At the time, he was the oldest archbishop in the United States. (Courtesy of the Archdiocese of Milwaukee Archives.)

THE RIGHT REVEREND MARTIN MARTY (1834–1896). Martin (born Alois) Marty, O.S.B., was from Canton Schwyz. He spent a brief time in Milwaukee with Archbishop Henni. In 1879, after years of missionary work with Native Americans, he was appointed vicar apostolic of Dakota, residing in Yankton. In 1889, Marty became the first bishop of Sioux Falls. Late in 1894, he was transferred to St. Cloud, Minnesota, where he died in 1896. (Courtesy of St. Meinrad Archabbey.)

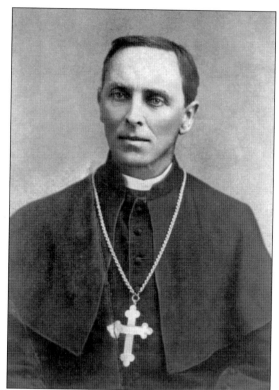

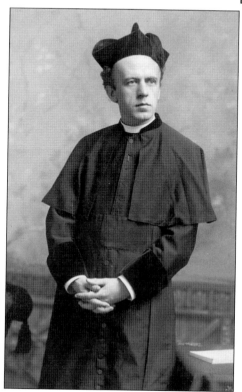

THE RIGHT REVEREND DR. ZARDETTI (1847–1902). John Joseph Frederick Otto Zardetti, childhood friend of Sebastian Messmer, was born and educated in Rorschach, St. Gallen. His ancestors had moved there from Italy in the 18th century. Fluent in four languages, Zardetti taught theology at St. Francis Seminary (1881–1887), until he was appointed general vicar of Dakota under Bishop Marty. Pope Leo XIII appointed him the first bishop of St. Cloud, Minnesota, in 1889. (Courtesy of the Archdiocese of Milwaukee Archives.)

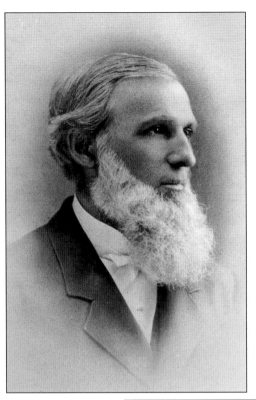

REV. WILHELM (WILLIAM) STREISSGUTH. Streissguth attended the Basler Academie in Basel, Switzerland. When he requested to do missionary work in Africa, he was sent to Alsace instead. Eventually he was called to New Glarus, Wisconsin. Streissguth served the congregation there for five years and then moved to Milwaukee, where he became pastor of St. Johannes (St. John's) Lutheran Church, on the corner of Fourth and Prairie Streets. He remained pastor until 1868. (Courtesy of the Wisconsin Historical Society.)

REV. FRIEDRICH MÖCKLI. Möckli was pastor of Emanuel Church on Ninth and Center Streets for about four years before this photograph was taken in 1904. He was born in Switzerland about 1841, immigrated in 1865, and went to Sheboygan, Wisconsin. His wife, Caroline, who was also Swiss, immigrated in 1871. She was treasurer of the Emanuel Ladies Aid Society. Pastor Möckli died in July 1915. (Author's collection.)

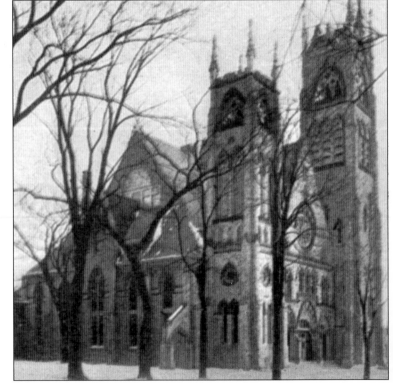

Four

POLITICS, EDUCATION, AND THE ARTS

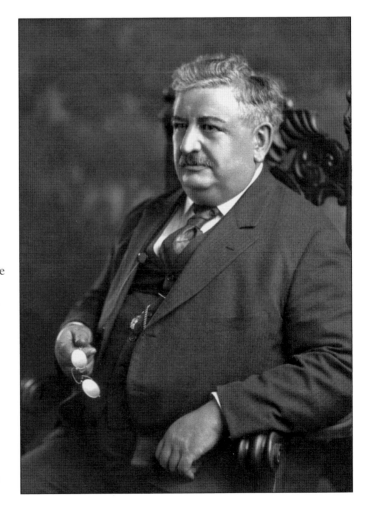

EMANUEL LORENZ PHILIPP. Philipp was born in Sauk County, Wisconsin, on March 25, 1861, to Luzi and Sabina (Ludwig) Philipp. His parents were natives of Zizers, Graubünden, who immigrated in 1849. Emanuel was a farmer, schoolteacher, telegraph operator, railway station agent, and he served as a delegate to the conventions that nominated Roosevelt and Taft for the presidency in 1903. He was a Milwaukee police commissioner from 1909 to 1914. A Republican and a Freemason, Philipp was elected governor of Wisconsin in 1914 and reelected in 1916 and 1918. He established the Department of Agriculture, the Conservation Commission, and a four-year medical course at the University of Wisconsin in Madison. (Courtesy of the Wisconsin Historical Society.)

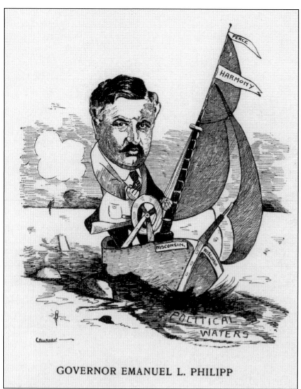

GOVERNOR EMANUEL L. PHILIPP

NAVIGATING THE POLITICAL WATERS. Philipp was serving a third term as president of the Milwaukee Chamber of Commerce when he died on June 15, 1925. After his death, the Wisconsin State Senate passed a resolution proclaiming that "during the critical time of the World War, Governor Philipp administered the state with prudence, and under his guidance Wisconsin acquired an enviable record." (Courtesy of the Milwaukee County Historical Society.)

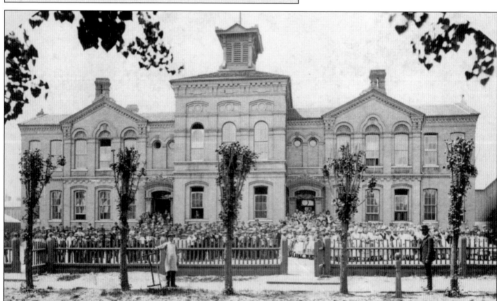

ALDERMAN. John Bächler, a carpenter and cabinet maker, born in Trub, Bern, on October 17, 1833, immigrated in 1852. He married Mary Hauswirth, also Swiss, in 1858. He owned a general merchandise business until his death in 1876. Bächler was the first alderman of the 10th Ward, school commissioner, and assessor. He owned property between Highland and Juneau, upon which the Tenth Street School, shown here, was built. (Courtesy of the Milwaukee County Historical Society.)

ALFRED BICKEL. Bickel was born in Canton Zürich in January 1850, immigrated in 1880, and died in Milwaukee in 1918. He was the "fusion" candidate for city coroner in 1896. The year before, he ran for supervisor in the Ninth Ward on the Populist ticket but was not elected. Bickel helped found *Helvetia*, a Swiss club, in 1882. He was a machinist employed by Weisel and Vilter Manufacturing Company. His wife was Katherine. (Author's collection.)

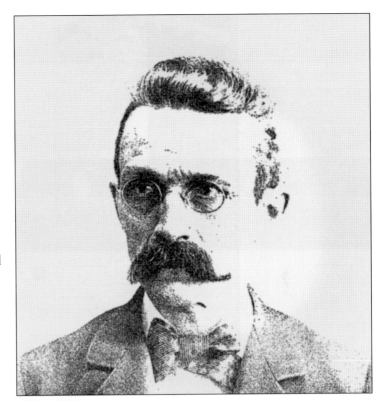

KINDERGARTEN PIONEER. Swiss native William Nicholas Hailmann (1836–1920) was a major force in 19th-century education. While living in Louisville, Kentucky, he administered a German American school with the first kindergarten class in the United States. Hailmann and his wife worked tirelessly to open kindergartens in many locations around Milwaukee. He was president of the Froebel Institute of North America and led the transition into the National Education Association's kindergarten department. (Courtesy of the La Porte County (IN) Historical Society Museum.)

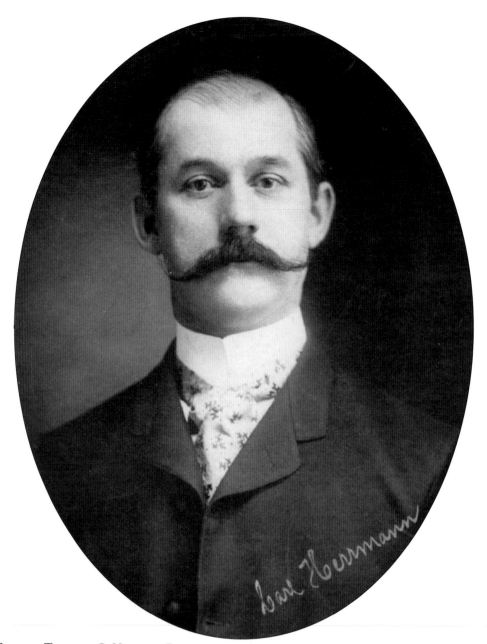

RADICAL THINKER. C. Hermann Boppe was a prominent journalist and an influential citizen of Milwaukee since 1877. He was the editor of *Der Freidenker* (the Free Thinker), the official organ of the North American *Turnerbund*, from 1879 to 1899. Boppe was one of the best-known members of the Turners in the city and was also a member of the Swiss Club and the *Freie Gemeinde*. A tireless promoter of women's rights, Boppe wrote on a variety of political and educational subjects, and he was widely known for his radical views. A native of Canton Aargau, he was born in June 1841 and died at the early age of 58 on January 18, 1899. He was buried in Forest Home Cemetery. At the time of his death, he was secretary of the National German American Teacher's Seminary, which he helped found in 1878. The seminary helped prepare bilingual students for teaching careers. (Courtesy of the Milwaukee County Historical Society.)

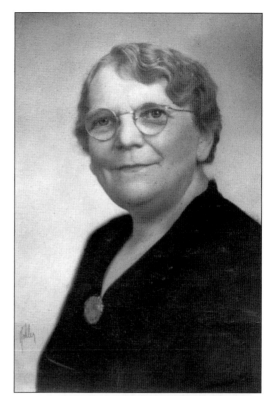

PIONEER IN RECREATION AND ADULT EDUCATION. Dorothy Caroline Enderis (1880–1952) was born in Elmhurst, Illinois, to Swiss immigrants. The family moved to Milwaukee a year later. After graduating from Milwaukee Normal School in 1901, Dorothy began her career with Milwaukee Public Schools in 1909. Before she retired as assistant superintendent, she already had an international recognition for her groundbreaking ideas in education. (Courtesy of Brian Hoffer, Milwaukee Public Schools Department of Recreation and Community Services.)

ENDERIS PARK. Dorothy Enderis is the namesake for this well-kept park and playfield, located in the heart of the city's northwest side, bordered by North Seventy-Second Street, West Chambers Court, and West Locust Street. The park hosts a variety of well-attended summer concerts and sponsors a lively Fourth of July celebration each year. The colorful *Magic Tree Grove* sculpture by Nancy Metz, installed in 2006, is a highlight. (Photograph by Maralyn A. Wellauer-Lenius.)

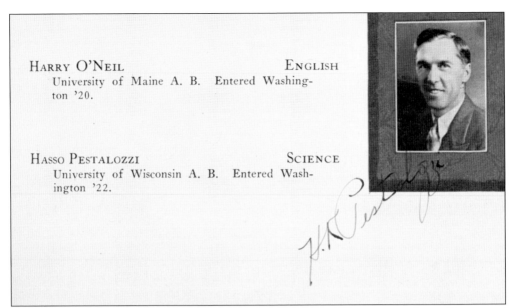

HARRY O'NEIL ENGLISH
 University of Maine A. B. Entered Washing-
 ton '20.

HASSO PESTALOZZI SCIENCE
 University of Wisconsin A. B. Entered Wash-
 ington '22.

HASSO PESTALOZZI (1895–1982). Pestalozzi was a University of Wisconsin graduate. He married Isabelle Hill in 1920 and two years later began his career with Milwaukee Public Schools teaching science at Washington High School (WHS). Years after, he was an MPS truant officer. The renowned Zürich-born educator, Johann Heinrich Pestalozzi (1746–1827), whose 19th-century reform efforts are still lauded today, was an ancestor. This autograph was inscribed into the 1927 *Scroll Annual* WHS yearbook. (Author's collection.)

DELEGATE. Gustav Arnold Schaefli was born in Switzerland in September 1861 and immigrated in October 1882. In July 1889, he attended the International Turnfest in Paris. He was a swimming instructor at Milwaukee's south side natatorium. Schaefli also taught calisthenics and was one of Wisconsin's delegates to the National Turner's Convention. He and his wife, Adelaide, had three children, Carl, Gustav, and Emma. (Courtesy of the Milwaukee County Historical Society.)

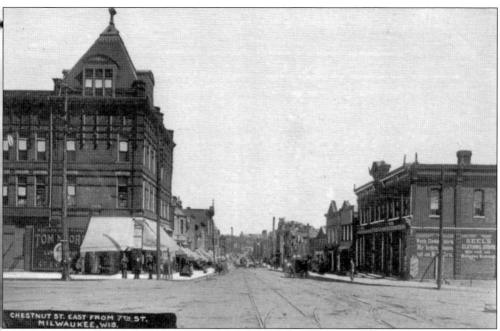

JEWELER. Joseph A. Sidler was born May 26, 1826, in Küssnacht, Zürich. A goldsmith and watch maker, Sidler owned a well-known jewelry shop on Chestnut Street. He entered the United States in March 1852, going first to Highland, Illinois (the site of a thriving Swiss settlement), then to New York, and finally to Milwaukee in 1856. Sidler married Johanna Peters. He died on Christmas Day 1894 and is buried in Forest Home Cemetery. (Author's collection.)

HENRY S. SUTTER. This prolific photographer worked from his studio located at 128 Wisconsin Street since 1874. He conducted a successful business all around the United States and maintained galleries in Milwaukee and Waukesha. Sutter was born in Zürich on February 11, 1853. He came to the United States when he was five years old with his parents, John H. and Katherine Sutter. Henry died in his Mason Street home on June 2, 1889. (Author's collection.)

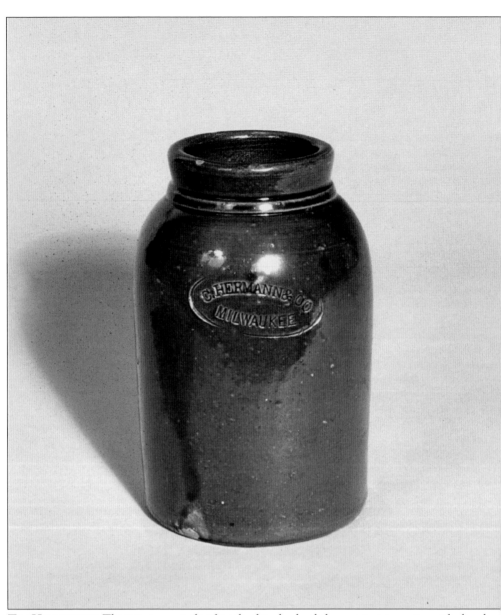

THE HERRMANNS. This prime example of a cylindrical, wheel-thrown stoneware jar with slip glaze was manufactured by the Herrmann pottery works on Johnson Street near the Milwaukee River. Raw clay was shipped in to the factory by Great Lakes schooners. The Herrmann (also Hermann) brothers established the largest stoneware manufactory in the city with the longest life. At one time, it was thought that Milwaukee would become a great pottery center, but it was never able to overtake the more dominant businesses in Ohio. Charles (Carl) Herrmann operated his shop from 1856 until 1886, when his stepson and partner, Louis Pierron, took over the firm. Christian (1816–1897) and Friedrich (1818–1885) Herrmann, born in Langnau, Bern, came to Milwaukee in 1847 and started the business. Their brother Carl Samuel (d. 1892), a tinsmith by trade, came to help with the business in 1849. Christian later opened a specialty shop with a tavern called *Zur Tells Kapelle* (Tell's Chapel). They were all musically inclined members of the *Schweizer Männerchor* and the Swiss Club. (Courtesy of the Milwaukee County Historical Society.)

Movie Mogul and Visionary. John Freuler was at the forefront of the developing motion picture industry. One of the first to see opportunities in renting movies to theaters, he founded the Western Film Exchange. After selling his Theatre Comique on Kinnickinnic Avenue, he produced his own films. Freuler personally contracted actor Charlie Chaplin in 1916 (some say he discovered him.) The famous director D. W. Griffith worked for him. Freuler came to Milwaukee in 1865 from Switzerland with his parents. His wife, Rosina Miller, was from Glarus. (Courtesy of the Milwaukee County Historical Society.)

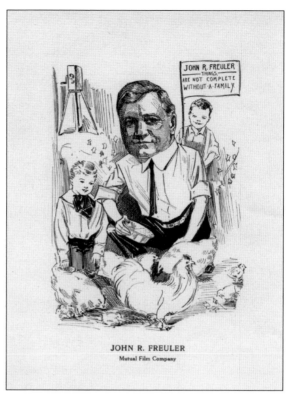

JOHN R. FREULER
Mutual Film Company

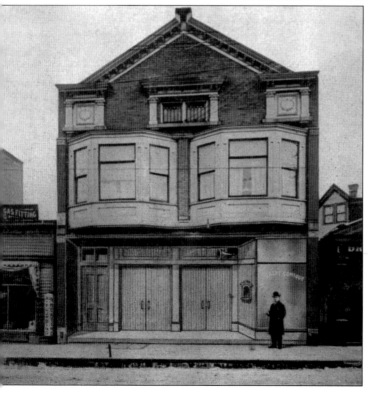

Milwaukee's Second Permanent Movie Theater, 1905. In an article featured in the *Milwaukee Journal* on December 6, 2005, Larry Widen wrote, "The Comique was a crude operation, with 200 chairs and a piece of white muslin tacked to the wall to serve as a screen." John Freuler said in a later interview, "There were no fire exits, and the ventilation was so poor that the projectionist sprayed perfume in the air at regular intervals." (Courtesy of the Jessie Walker Collection and Larry Widen.)

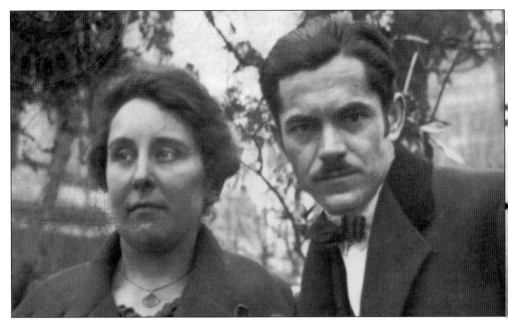

SCULPTOR. Albert Ulrich Langenegger (1889–1964), the Münich-born citizen of Gais, Appenzell Ausser-Rhoden, worked quietly and was virtually unknown for years, creating some of the most beautiful stone carvings and memorials in the Midwest. After arriving in Milwaukee in 1924 with his first wife, Prisca (shown here), he became president of Architectural Carving Company, Inc. (also known as Langenegger and Kellenberg), with a studio located at 5024 North Thirty-third Street. His memorial business was eventually sold to the Stotzer Granite Company, another Swiss-owned business. (Courtesy of Bert Langenegger.)

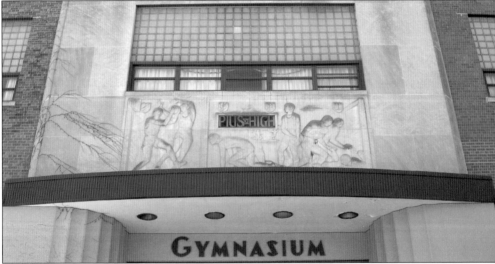

PIUS XI HIGH SCHOOL. Albert U. Langenegger's stonework adorns many Milwaukee landmarks, including Rufus King High School and Trinity Episcopal Church in Wauwatosa. The Swiss sculptor's exceptional talent and creativity can be seen in the intricate tableaus above the entranceway to Pius XI High School at 135 North Seventy-sixth Street. Langenegger married Jeanette Grob, daughter of John Jacob Grob from Glarus, in 1927. They had two children, Albert and Jean. (Photograph by Maralyn A. Wellauer-Lenius.)

OSCAR FREDERICK STOTZER (1884–1964).
Oscar's father, Samuel, was a master
sculptor and stone carver from Büren an
der Aare, Bern. He founded the Stotzer
Granite Company in Portage, Wisconsin,
in 1876. His mother, Anna Rohrer, was
also from Switzerland. Oscar (shown
at right) and his brother expanded the
business and moved it to Milwaukee
in 1913 after their father's death. It
subsequently became the largest exclusive
producer of monumental works west of
Barre, Vermont. (Author's collection.)

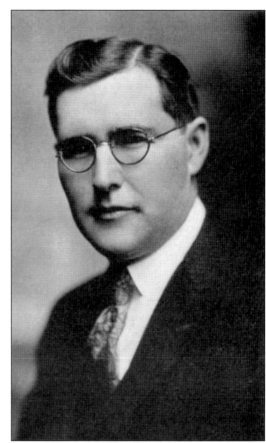

STOTZER BUILDING. This art deco/
moderne–style building stood on
the current site of the Marquette
University dormitory tower at Tenth
and Wells Streets. The first location
of the Stotzer Granite Company was
723–727 Grand Avenue (now Wisconsin
Avenue) downtown. The family-run
business was later moved to Sixty-third
Street and Appleton Avenue. The
Stotzer family sold it to Rock of Ages
Memorial Company, Inc., in 1983.
(Courtesy of the Historic Photographic
Collection/Milwaukee Public Library.)

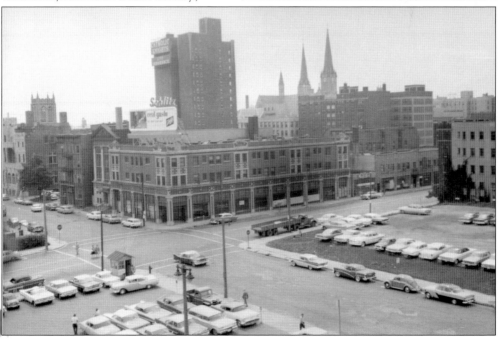

Mayad Dolls. Milwaukee artist Nell (Kindlimann) Weidmann, a native of Zürich, came to Wisconsin with her husband, Siegfried, and their young daughter in 1954. She studied many mediums—watercolor, oil, and porcelain—before creating her beloved dolls in 1974. Her show, "An Exhibition of Swiss Costume Dolls," which ran from June through November 1985 at the Milwaukee Public Museum, was viewed by many appreciative visitors. (Courtesy of Nell Weidmann.)

Native Trachten in Miniature, 1975. The dolls' brand name, Mayad, is a combination of Weidmann's children's names, Maya and Adrian. Her work, which was once part of the Swiss Society Craft Exhibition, has also been featured at the Swiss Center in New York City. Weidmann was active in the Swiss Ladies Society of Milwaukee for many years and is a past president. (Courtesy of Nell Weidmann.)

SWISS CLOCK. One of the most prominent and delightful features in the European Village exhibit at the Milwaukee Public Museum is the Swiss clock tower. Her largest undertaking ever, Nell Weidmann painstakingly hand painted the clock face in 1979. She accomplished this feat of drawing and painting while standing on a scaffold. The museum is located on Wells Street between Eighth and Ninth Streets. (Courtesy of Nell Weidmann.)

Erzählen wird man von dem Schützen Tell,
solang' die Berge stehn auf ihrem Grund.

TELL—THE LEGEND. On one side of the clock, the four languages of Switzerland—German, French, Italian, and Romansch—are depicted, and on the other side, the legend of Wilhelm Tell unfolds. The message on the clock face, as shown here, reads, "One will talk about the archer, Tell, as long as the mountains stand on the ground." (Courtesy of Nell Weidmann.)

STATUE. This imposing bronze likeness of Baron Frederick von Steuben, German hero of the American Revolutionary War, is a landmark on the northwest side. It guards the entrance of Washington Park on the south end of Washington Boulevard. Sculpted by Swiss-born artist J. Otto Schweizer, it was dedicated in July 1921. Schweizer crafted two other von Steuben monuments. One is located in New York City and another in Utica, New York. (Photograph by Maralyn A. Wellauer-Lenius.)

MILWAUKEE ART MUSEUM. The spectacular new wing of the Milwaukee Art Museum was designed by Spanish-born, Swiss-based architect Santiago Calatrava. It is a most captivating and beautiful addition to the landmarks along the shore of Lake Michigan. Calatrava has blurred the line between engineering and architecture. Works by many world-renowned Swiss artists, such as Karl Bodmer, Paul Klee, and Mario Botta, are represented in the art center's collection. (Photograph by John December, author's collection.)

Five

FAMILY DYNASTIES

THE COMPANY OF GIANTS. Robert Nunnemacher's portrait is displayed alongside some of the
[w]ealthiest and most successful businessmen in America, like J. Pierpont Morgan, John D. Rockefeller,
[an]d Cornelius Vanderbilt. Nunnemacher was born on April 7, 1854. After graduating from
[Mi]lwaukee's exclusive German-English Academy, he attended Notre Dame University. He was
[aff]iliated with the Merchants Exchange Bank and American Malting Company in the 1890s.
[Nu]nnemacher was a trustee of the Milwaukee Public Museum and a member of the Milwaukee
[Cl]ub. He was a member of one of Milwaukee's pioneer families of Swiss origin. Members of
[the]se families in the first or second generations became Milwaukee's own captains of industry.
[Nu]nnemacher died on March 8, 1912. (Courtesy of the Milwaukee County Historical Society.)

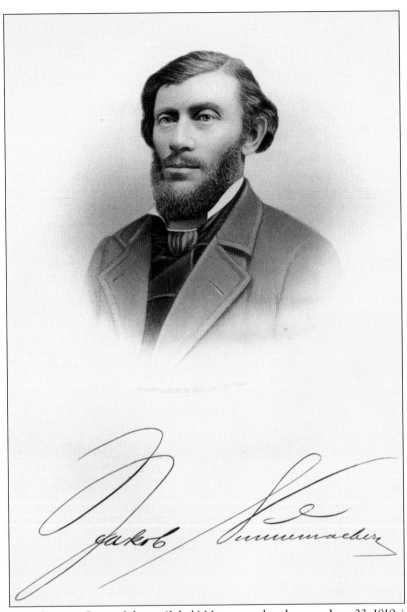

AN AMERICAN SUCCESS STORY. Johann (Jakob) Nunnemacher, born on June 23, 1819, in Cant[o]
Basel, was the progenitor of a family dynasty in Milwaukee. His Catholic father, Gaudenz, w[as]
born on August 1, 1781, in Staufen, Bern. His mother, Appolonia Sigrist, was a Protestant Fren[ch]
Huguenot. The couple left Baden and went to Switzerland in 1818. There they were hotel keepe[rs]
and traded cattle. Johann Jakob married a German girl, Catherine Bargenbruch. She was born [on]
March 16, 1820, in Karpstedt. Jakob and his older brother Heinrich immigrated in February 184[4.]
Jakob established himself in the meat business (*Gasthofe zum Lamm*) in Milwaukee in 1844 a[nd]
was very successful. Heinrich, born in 1812, established a potter's shop and grocery the first ye[ar]
he arrived in the city. He later opened a hotel for immigrants called *Zu den drei Eidgenossen*, whi[ch]
undoubtedly makes reference to the three original forest cantons of the Swiss confederation. Jak[ob]
died on October 28, 1876, and was survived by his sons, Rudolph, Jacob, Robert, and Herman[n.]
He and his wife were buried in Forest Home Cemetery. (Author's collection.)

Humble Beginnings. This old, wooden structure, surrounded by a picket fence, was the first residence of Jakob Nunnemacher after he arrived in Milwaukee from Canton Basel in 1843. It provides a rare view of an original home of an early Milwaukee Swiss immigrant. Later Nunnemacher owned a prosperous distillery, liquor business, and large tracts of land in the city, including extensive acreage in the town of Lake. (Courtesy of the Historic Photographic Collection/ Milwaukee Public Library.)

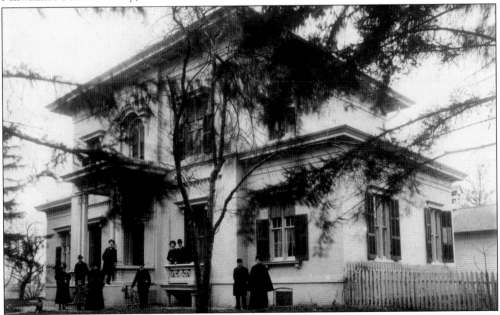

South Side Distillery. Jakob Nunnemacher sold his distillery, located near what is now Twenty-seventh Street and Oklahoma Avenue, to the Kinnickinnic Distilling Company. The stately Italianate structure is now the Evergreen Hotel and Bar. Visitors can still see a map of the old distillery inside the building. Family members identified in the photograph are Tilly, Martha, Robert, and "uncle and aunt." (Courtesy of the Milwaukee County Historical Society.)

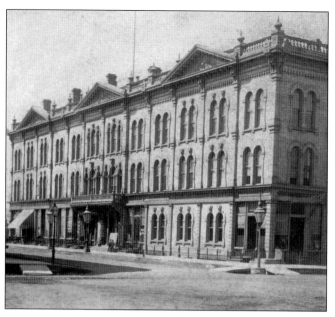

NUNNEMACHER'S GRAND OPERA HOUSE. Milwaukee's first premier theater was a three-story brick building complex with space for offices and shops. It was constructed in 1871 on the corner of Oneida and River (now Wells and Edison) Streets by Jakob Nunnemacher and his son Hermann. Jakob's other son, Jacob, was manager. One of Milwaukee's oldest theaters, together with the Academy of Music, it hosted many fine performances. The structure was located in the German theater block. (Courtesy of the Wisconsin Historical Society.)

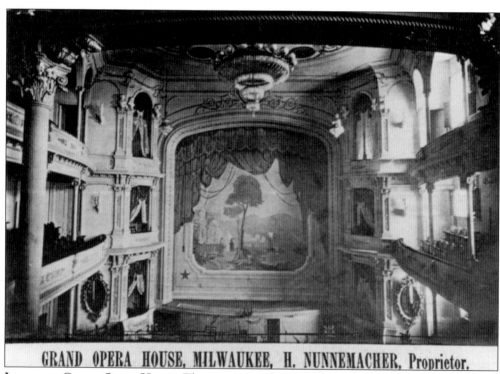

GRAND OPERA HOUSE, MILWAUKEE, H. NUNNEMACHER, Proprietor.

INSIDE THE GRAND OPERA HOUSE. The interior was lavishly adorned with marble, gold and silver frescoes, inspirational statues and busts of renowned composers and musicians, and magnificent cluster chandeliers. The Nunnemachers were involved with the theater for 20 years, until they sold it to Capt. Frederick Pabst in 1890. He renamed it the Stadt Theater in 1892, and it was eventually destroyed by fire. (Courtesy of the Milwaukee County Historical Society.)

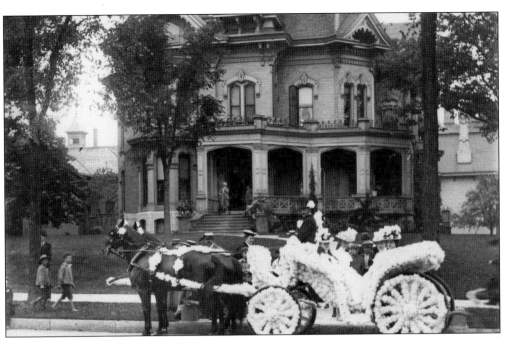

OLD HOME. The grand residence of banker and capitalist Rudolph Nunnemacher was located at Seventeenth Street and Grand Avenue. The property was later donated to the Milwaukee Children's Hospital. Marie Nunnemacher and Erna and Hilda Schmidt are three of the young passengers pictured in the carriage. Rudolph, born on September 7, 1848, began his career as a cashier at the Home Savings Bank. He was a director of Milwaukee Mechanics' Insurance Company. (Courtesy of the Milwaukee County Historical Society.)

ARTISTIC TRIBUTE. A magnificent monument in Milwaukee's historic Forest Home Cemetery was erected to the memory of a loved one who died young. It reads, "In memory of Pauline, beloved wife of Rudolph Nunnemacher, July 26, 1854, May 4, 1883." Rudolph Nunnemacher also met an early death in Meran, Tyrol, Austria, at Christmastime in 1894. He was vice president of the First National Bank. (Photograph by Maralyn A. Wellauer-Lenius.)

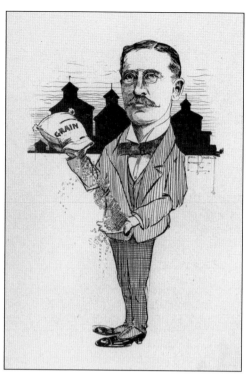

ROBERT IN CARICATURE, 1904. In 1881, Robert Nunnemacher formed a partnership with F. Kraus in the grain and shipping business under the firm name of F. Kraus and Company. In 1886, he partnered with William Faist. Later he became president and secretary of F. Kraus-Merkel Malting Company of Milwaukee, a large firm. Their expansive plant on South Water and Park Streets had a capacity of two million bushels of malt. (Author's collection.)

HOME OF A BYGONE ERA. Robert Nunnemacher built this home below at 1886 Jefferson Street. When this photograph was taken, the house was in the process of being demolished, one of the last ones standing on the block. It was a victim of the urban renewal projects on Milwaukee's lower east side in the 1960s. Robert's daughter Anita Nunnemacher Weschler and her brother were born in this house. (Courtesy of the Milwaukee County Historical Society.)

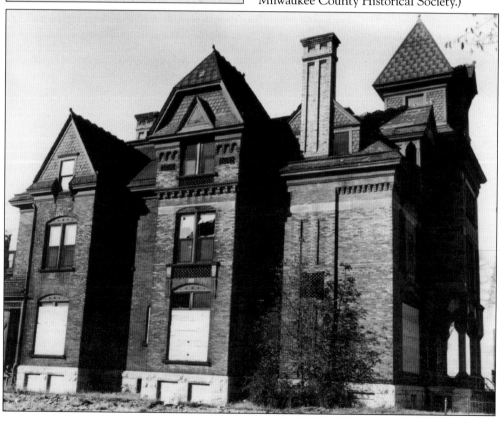

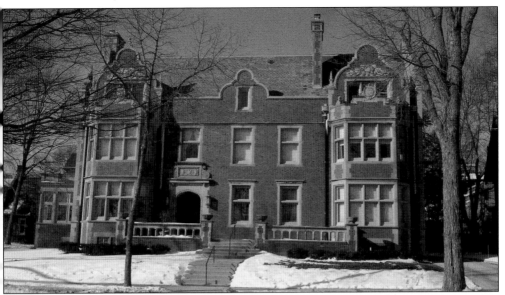

LAKEVIEW HOME. The able architect Alexander C. Eschweiler designed this spacious mansion, located at 2409 North Wahl Avenue, for the Nunnemachers after the style of the old manor houses of 17th-century England in 1906. The mansion was sold in 1928, and it became the rectory for St. Mark's Episcopal Church. Sometime during the 1960s, the old house was converted into apartments. (Photograph by Maralyn A. Wellauer-Lenius.)

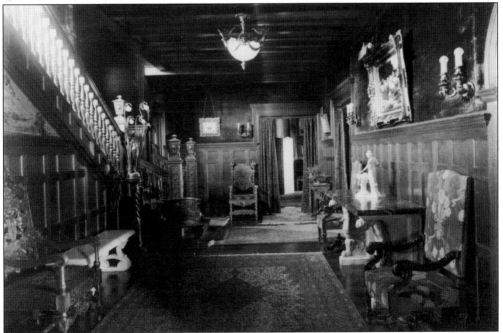

THE HALLWAY, AUGUST 1906. The exterior of the stately Nunnemacher house is redbrick and limestone, with wrought iron and leaded glass decorations. Photographs of the interior were taken after decorating was completed. In this rare glimpse into a private space, the downstairs hallway is visible in all its splendor. Every room was elegantly appointed with rare and beautiful items, both domestic and from abroad. (Courtesy of the Milwaukee County Historical Society.)

WELLAUER GRAVESTONE. This monument marks the graves of three brothers—Rudolf, (1808–1894), Konrad (1809–1888), and Georg (1811–1862)—in Forest Home Cemetery. The brothers were born in Wagenhausen, Thurgau, sons of Heinrich and Margartha (Keller) Wellauer. Konrad, a cabinet maker, helped introduce the cheese industry into Wisconsin. He operated three factories in Dodge County. He came to America with six friends in 1834. Konrad ran a specialty shop in Augusta, Georgia, before coming to Milwaukee in 1850. He founded Jacob Wellauer and Company with his nephew. (Photograph by Maralyn A. Wellauer-Lenius.)

JOHANN RUDOLF WELLAUER. Rudolf (Rudolph) and his family left Le Havre on the ship *Virginia* on May 16, 1849, and arrived in New York on July 2, 1849. He purchased an 80-acre farm in Section 36 of the town of Brookfield. His wife, Maria Elisabeth (Buel) Wellauer, was born on January 1, 1821, in Stein am Rhein, Schaffhausen, and died in 1857. After her death, Rudolph was a teamster and grader in Milwaukee before returning again to his farm. (Photograph by Maralyn A. Wellauer-Lenius.)

THE HENRY WELLAUERS. Johann Heinrich (Henry) Wellauer, shown at right, was born on September 24, 1797, in Wagenhausen, Thurgau. His wife, Anna (Vetterli), shown below, was born in the nearby village of Etzweilen on March 24, 1799. They had nine children, all born in Thurgau. Like his brother Rudolph, Henry's family sailed from Le Havre on the ship *Virginia* on May 16, 1849. After a difficult ocean journey, they disembarked in New York on July 2. They remained in Buffalo, New York, for about six months while working to make money for their passage inland. Henry purchased an 80-acre farm in Brookfield, Wisconsin, in 1850, and he and Anna lived there until they were unable to continue farming. The couple moved to Milwaukee in 1862, and they lived there comfortably until Anna's death on June 30, 1872, and Henry's death on March 16, 1883. They are buried in Forest Home Cemetery in Milwaukee. Most of their children married Swiss immigrants (Henry Breu, Henry Kuhn, John Ryf, and Anna Peter) and remained in Waukesha or Milwaukee Counties for much of their lives. (Courtesy of Mary K. Reddy.)

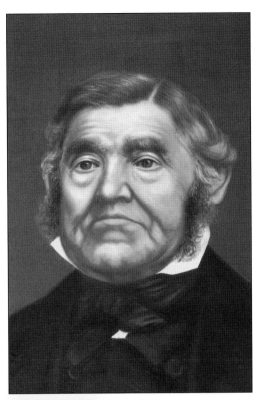

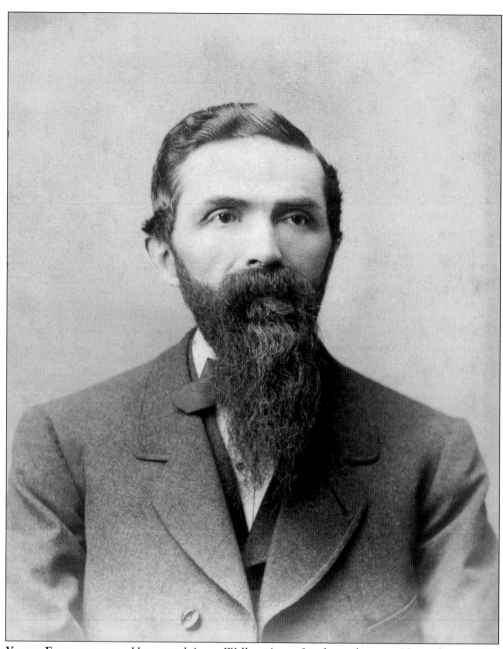

YOUNG ENTREPRENEUR. Henry and Anna Wellauer's son Jacob was born on November 6, 1840, and came to Wisconsin when he was nine years old. After spending his youth on the family farm in Brookfield, Jacob went to Oshkosh, Wisconsin, where he learned to make cheese. In 1863, he moved back to Milwaukee, where he started a wholesale and retail fancy grocery business, mostly with borrowed money and $150 of his own. (Courtesy of Mary K. Reddy.)

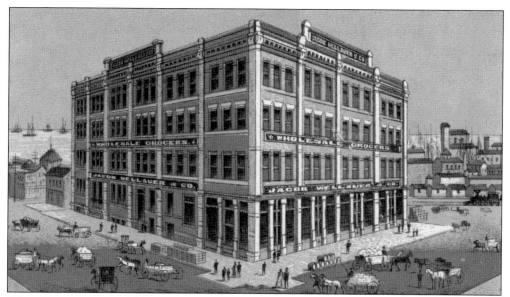

WAREHOUSE, 1886. Wellauer imported and manufactured cheese and sausage. After realizing considerable success in his ventures, he sold his retail business in 1872 and concentrated on an exclusive wholesale grocery, which he grew into one of the biggest in the Northwest. The *Milwaukee Sentinel* proclaimed on January 2, 1887, "The most successful Swiss in Milwaukee is undoubtedly Jacob Wellauer." He retired from active business in 1897. He was a generous patron of the Swiss Club. (Author's collection.)

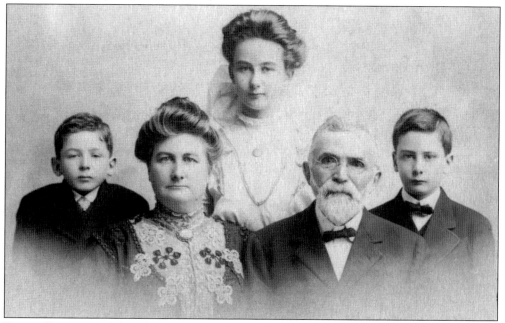

FAMILY PORTRAIT. After the death of his first wife, Anna (Hahn) Wellauer, Jacob married Magdalena Offerman on May 11, 1892. The couple was photographed with their three children, from left to right, Jacob Henry (b. September 23, 1896), Anna Magdalen (b. October 6, 1894), and Henry Conrad (b. April 27, 1898). Jacob Sr. died from pneumonia on January 10, 1916, as a result of climbing onto his roof on a rainy day. (Courtesy of Mary K. Reddy.)

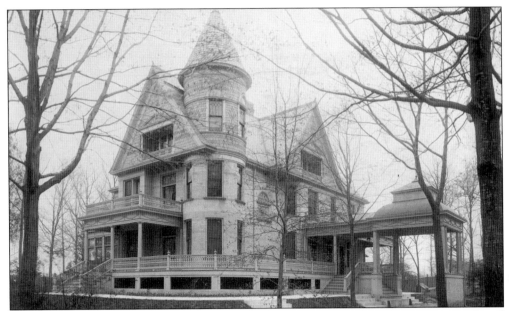

A 160-ACRE ESTATE. Live deer, monkeys, a pony, and an assortment of other "pets" once shared this estate on Wellauer Drive at Blue Mound Road and Seventieth Street in Wauwatosa with the family. Jacob Wellauer was an avid hunter who proudly displayed his many trophies, stuffed birds, and guns on the walls of exquisitely paneled rooms. This architectural masterpiece was demolished in the summer of 1940. It was a remnant of an extensive Wauwatosa farm that supplied Wellauer's grocery business. (Courtesy of Mary K. Reddy.)

WELLAUER BUILDING. This formidable five-story brick and steel building on the corner of Seventh and West Michigan Streets in downtown Milwaukee ("Kilbourn Town") was part of Jacob Wellauer's vast real estate holdings. It was constructed by Swiss architect Henry Messmer and Sons in 1910. The Campbell Laundry occupied the lower floors, and a business college leased the upper floors. It is still owned by one of Jacob Wellauer's descendants. (Photograph by Maralyn A. Wellauer-Lenius.)

GALLUS ISENRING (1826–1905).
Born in Ebnat, St. Gallen, Isenring
came to Milwaukee on June 15,
1847, and worked on a farm. Later
he opened a grocery and dry goods
store on Third Street and remained
in business until 1888. He owned
a saloon at 678 Ninth Street and
was active in the Swiss Club.
Isenring was road commissioner and
constable in the town of Milwaukee
for two years, town treasurer in
1859, and county supervisor in
1862. (Author's collection.)

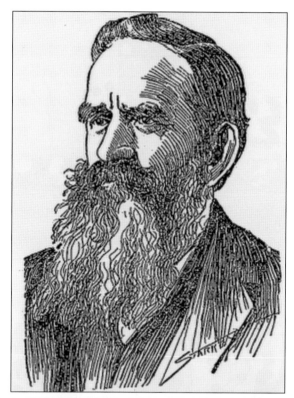

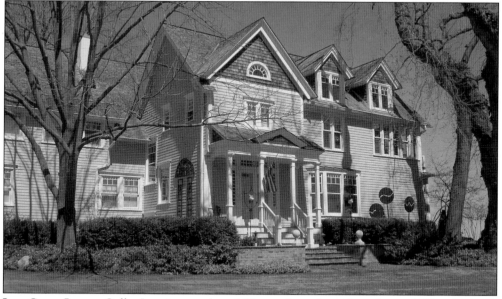

LOG CABIN INSIDE. Gallus Isenring purchased 15 acres from the widow of one of Whitefish Bay's
earliest settlers, William Consaul. There he built a log cabin that some believe may still be part
of a vastly remodeled home that still stands at 808 East Lake View Avenue, Whitefish Bay (a
suburb of Milwaukee), Wisconsin. In 1851, Isenring married Wilhelmina Zetteler, a Dutch woman.
They had four children, Frederick G., William, Anna, and Mary. (Photograph by Maralyn A.
Wellauer-Lenius.)

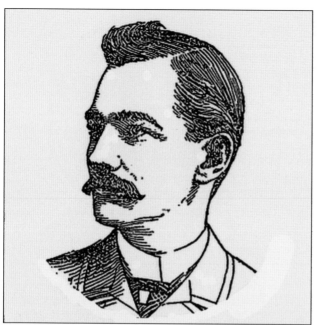

WHITEFISH BAY'S FOUNDER AND FIRST PRESIDENT. Frederick G. Isenring was born April 1, 1854, in Milwaukee. He married Hepworth Sophia Chandler. He was elected to the Wisconsin legislature in 1884, representing the 10th Assembly District of Milwaukee County. Two years later, he was elected to the state senate, but due to a reapportionment error, he was not permitted to take the seat. Isenring was elected chairman of Milwaukee County Board of Supervisors in 1892. (Author's collection.)

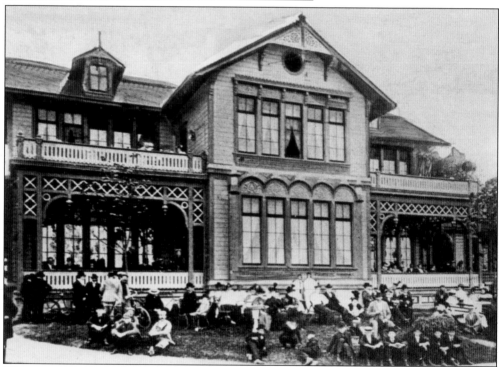

WHITEFISH BAY RESORT. Real estate broker Fred Isenring purchased this resort, which was 6 miles north of the Milwaukee city limits, for $1,600. He later sold it to the Pabst Brewing Company for $20,000 in 1888. The nationally known attraction was located at the intersection of North Lake Drive and East Henry Clay Street. Thousands crowded in on streetcars and bicycles from Milwaukee. Fine music and whitefish dinners attracted visitors. (Courtesy of the Historic Photographic Collection/Milwaukee Public Library.)

Prolific Architect. Among the old pioneer architects of the city, perhaps none are as well remembered by the number of massive buildings as Henry Messmer (1839–1898). Messmer was born in Rheineck, St. Gallen. Immigrating in April 1867, he traveled directly to Milwaukee, where he collaborated with architect L. A. Schmidtner to design the new courthouse. In 1873, he went into business with his son Robert. Their headquarters were located in the old Grand Opera House. (Author's collection.)

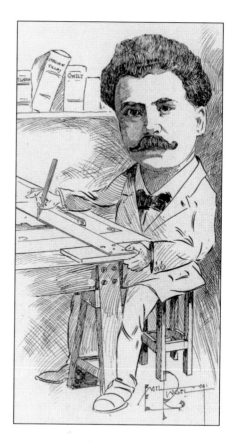

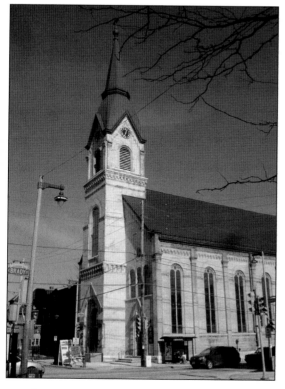

Landmark on Brady Street. St. Hedwig, St. Hyacinth, St. Vincent de Paul, SS. Peter and Paul, and St. Josaphat were some of the most impressive edifices Messmer built in Milwaukee. St. Hedwig's church, shown at left, is located on the lower east side. It was built in 1886 for the city's second Polish-speaking Roman Catholic congregation. Recently it was rechristened Three Holy Women when St. Hedwig's, St. Rita's, and Holy Rosary parishes merged. (Photograph by Maralyn A. Wellauer-Lenius.)

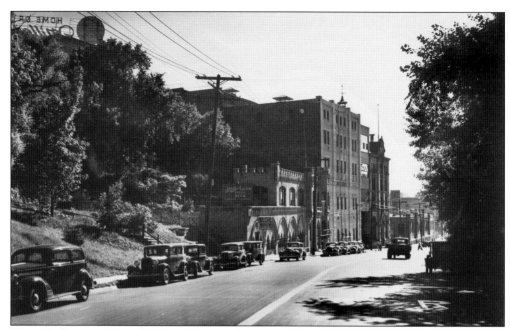

MILLER'S GARDEN. Two of Henry Messmer's larger commissions were Obermann and Company's ice and malt houses and dwellings and Miller's Garden for Fred Miller. This included an icehouse, offices, and cellar, which extended for 250 feet under a hill. Originally Miller's Garden, located on the west end of Wells Street, was one of the city's three major beer gardens, together with Schlitz and Pabst Parks. (Courtesy of the Wisconsin Historical Society.)

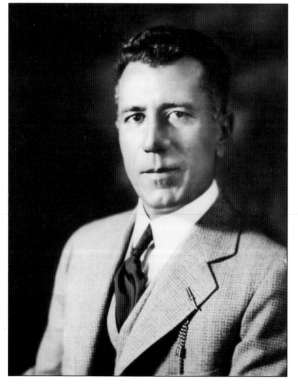

SUPERINTENDENT OF CONSTRUCTION. John Messmer, son of Henry and Barbara (Rieck) Messmer, was born in Milwaukee on September 23, 1884. After college, he supervised the construction of practically every large school in Milwaukee and every new structure in the county from 1913 to 1926, except the House of Correction and the county agricultural building. John was elected to the Wisconsin Athletic Hall of Fame in 1959. (Courtesy of the Milwaukee County Historical Society.)

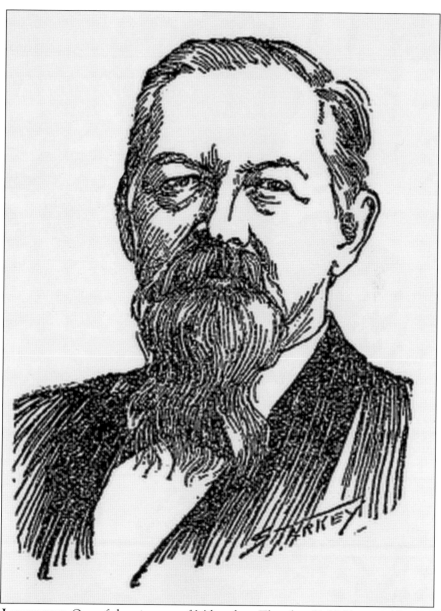

THE HABHEGGERS. One of the pioneers of Milwaukee, Theodore E. Habhegger (shown above) was also one of the founders of the Milwaukee Swiss Club and its treasurer for 11 years. He was born on May 13, 1830, in Langnau, Bern, to Ulrich Habhegger (b. July 8, 1787, in Langnau) and Anna Maria (Lehmann) Habhegger (b. May 13, 1789). Theodore arrived in Milwaukee with his mother and his brother Christian in July 1849. Christian kept a detailed, illustrated journal of the difficult journey. He was born on February 28, 1828, in Langnau. He married Lina Habegger, daughter of Friedrich W. and Maria Habegger. (Despite the fact they had similar names, Christian said they were not related.) Christian died in November 1910. Theodore Habhegger was one of the founders (in 1865) of the First German Reformed Church, one of the oldest in the city. Theodore married Anna Maria Klaus, also a Swiss immigrant, in 1860. They had seven children, two of whom died in infancy. The surviving children were Sophia (who married Frank Karow), Albert C., Theodore F., Otto J., and Charles G. (Author's collection.)

MASTER WAGON MAKER. Theodore Habhegger spent six years learning the blacksmith and wheelwright trade from J. Kingsley (on River and Oneida Streets). He partnered with his former boss George Haekler until 1876, and they ran a successful business at 568 Market Street under the name Habhegger and Company. Theodore produced quality-crafted wagons for dairies, florists, grocers, and other businesses in Milwaukee and Waukesha. These images recall a bygone era when goods were delivered by horse and wagon, not motorized transport. One of Habhegger's original catalogs, containing images of 37 wagons dating back to the turn of the 20th century, is preserved in the Milwaukee Public Library. Theodore continued producing carriages, buggies, and sleighs until his death in 1901. (Courtesy of the Historic Photographic Collection/Milwaukee Public Library.)

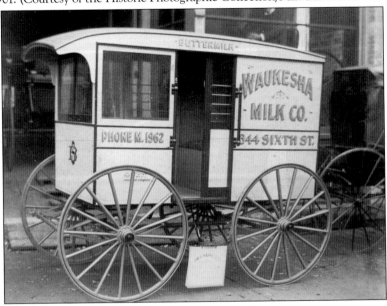

SAVORING A GOLDEN MOMENT. A grandfather's tender touch lights softly on the hand of grandson Elmer Otto Habhegger. Elmer, born January 2, 1896, was the son of Otto John and Katherine (Buestrin) Habhegger. Grandpa Theodore died shortly after this photograph was taken on January 31, 1901. He was longtime treasurer of the Swiss Club, *Schweizer Männerchor,* and other organizations. (Courtesy of Prof. Donald and Barbara Rambadt.)

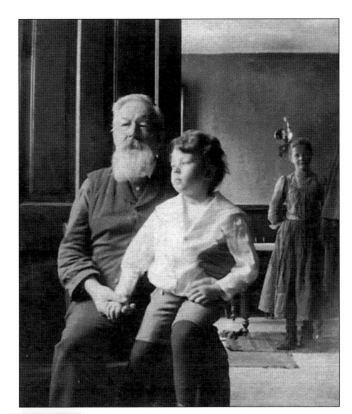

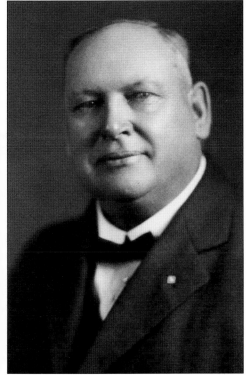

THEODORE F. HABHEGGER. Theodore Sr. passed on his successful business to his two sons and then to a third generation. His son Theodore was born on April 25, 1866, in Milwaukee. After working in his father's shop, he traveled to Chicago and Detroit to broaden his knowledge of the carriage industry. He married Johanna N. Edlefsen, and they had three children, Irene, Theodore, and George. (Courtesy of the Milwaukee County Historical Society.)

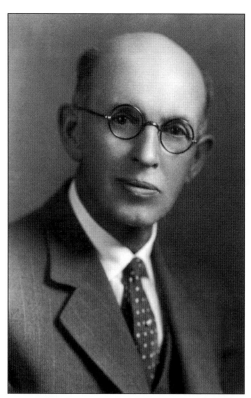

ALBERT C. HABHEGGER. Albert helped Theodore, his younger brother, carry on the business. Albert was born on April 5, 1863, in Milwaukee. In 1888, he married Augusta Kratz. Both Albert and Theodore were members of Milwaukee's Old Settler's Club and the Masons. (Courtesy of the Milwaukee County Historical Society.)

WHEEL AND AXLE SHOP EXTERIOR. In the early 1900s, Habhegger's business shifted from carriage manufacture and blacksmithing to automobile repairs, particularly frame straightening and work on wire wheels. The old location at 1316 North Water Street was razed for the Park East Freeway. The business is still operating at 1709 North Water Street. (Courtesy of the Historic Photographic Collection/Milwaukee Public Library.)

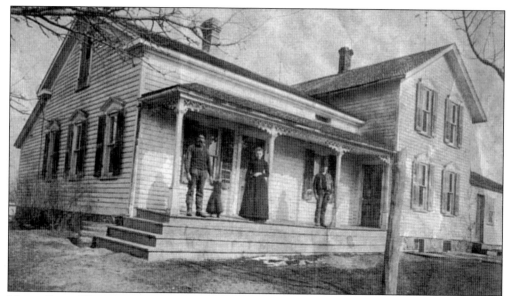

MEYER-ROHR HOMESTEAD. This family farm, a successful orchard for years, is one of the oldest homesteads in Oak Creek (Milwaukee County). From left to right are Frederick, his young son Alfred, his wife, Selma Meyer, and hired man Mike Cyganick enjoying life on the porch of the family home in 1891. Originally a two-room house, it was built by Fred's father, Joseph Alois Meyer (1804–1890), a cabinet maker from Weltenschwyl, Aargau. He immigrated in 1834. (Courtesy of Barry Meyer.)

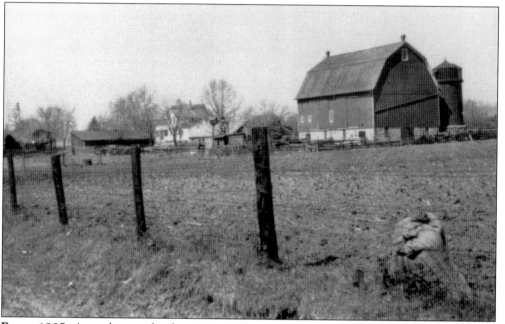

BARN, 1905. According to the description in his passport, Joseph Meyer had black hair and a "perfect face." He served one term in the state assembly in 1853. Then he began farming with his Swiss wife, Anna, and her father, Jacob Rohr. Joseph built the barn shown here in 1877. It was made of hand-hewn oak beams and ironwood for joists. In 1910, Joseph's grandson built a larger, hip-roofed barn next to the older structure. (Courtesy of Barry Meyer.)

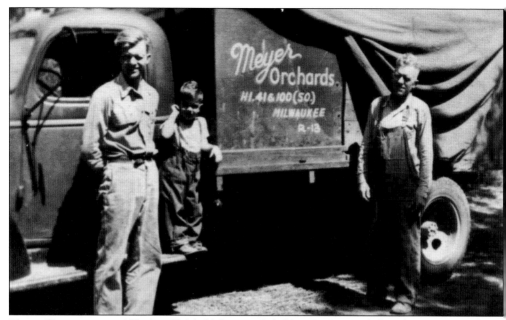

THREE GENERATIONS. Alfred and Mabel Meyer and children Le Roy, Isabel, and Armin moved into the main house in 1913 and named it "Shady Lawn Farm." Alfred expanded the apple orchard, for which the family was well known by 1929. Designated a landmark in 1990 by the Milwaukee County Historical Society, the property was continuously occupied by the Meyer family for six generations. Alfred, LeRoy, and his son Barry posed by their truck. (Courtesy of Barry Meyer.)

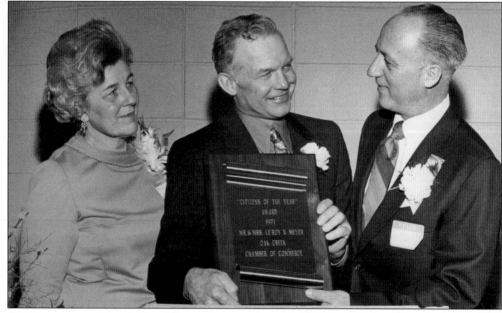

CITIZENS OF THE YEAR. LeRoy Meyer, who served on the Oak Creek School Board, and his wife, Beulah, were presented with the Citizens of the Year Award at the annual Oak Creek Chamber of Commerce dinner in 1971. Both were active in the local historical society. The president of the chamber of commerce presented the plaque to the couple in recognition of years of service to the community. (Courtesy of Barry Meyer.)

Six

POPULATING WAUKESHA COUNTY

PLAT MAP, 1873. A portion of the fast-growing Milwaukee County was reapportioned to create Waukesha County early in 1846. Friedrich Hasler and his Connecticut-born wife went to Genesee, and Henry Kunz (Kuntz) and his family settled in Monches. They were the first Swiss in the area in 1841. The town of Brookfield had the most sizeable settlement in the county by the 1840s. It was primarily an agricultural community, but had an urgent need for blacksmiths, coopers, wagon makers, carpenters, and stonemasons. Names of early pioneer Swiss families can be found in the early plat books and parish registers of Waukesha County. (Author's collection.)

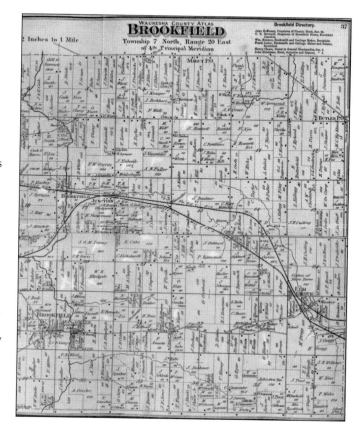

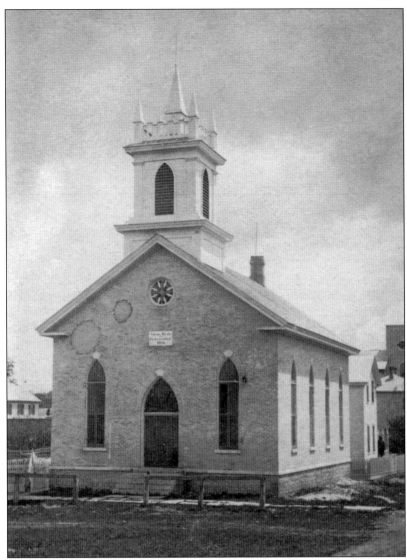

First German Reformed Church, Waukesha (1866–1891). Strong evidence of one of the largest concentrations of Swiss in a Protestant congregation in this area can be found in the parish registers of the First German Reformed Church, first located at the corner of Barstow and South Streets. Baptisms, marriages, and burials were performed for members of the following families: the Baldinger and Künzli (Muhen) families from Canton Aargau; the Baumgaertner (Bittwil), Buehler (Oberwil), Bürri, Butschli (Oberbipp), Dinkelmann, Dreher, Gerber, Gygax (Seeberg), Hauswirth (Saanen), Leunenberger, Maurer, Schmutz, Waegli, and Winzenried (Belp) families from Canton Bern; the Staub family from Canton Glarus; from Canton Luzern the Fischer (Triengen) and Zbinden families; the Beller family from Canton St. Gallen; the Breu, Hoffmann (Horgenbach), Ochsner and Wellauer (Wagenhausen), and Peter families from Canton Thurgau; and the Wepfer (Stammheim) family from Canton Zürich. Those identified only as being Swiss include the Aeschimann, Buess, Egg, Geiser, Lohry, Pfund, Salm, Steinmann, and Yennie families. The names of other Swiss—Batalia, Brungger, Frey, Frick, Gasser, Habert, Niederer, Romang, Rudolf, Schlintz, Streiff, and Tesch (Tish)—who stayed briefly in the county, can only be found on census lists. (Courtesy of the Waukesha County Historical Society and Museum.)

ELM GROVE, C. 1910. A wooden plank road (a toll road until 1901) connected Milwaukee with the interior since 1846. It facilitated a brisk trade between farms in Waukesha County and markets in Milwaukee. Many Swiss farmers walked from Elm Grove and Brookfield to the city on the old road with produce on their backs, or they traveled by wagons. In February 1851, the Milwaukee and Mississippi was the first railway company to run its train from Milwaukee to Prairieville. (Author's collection.)

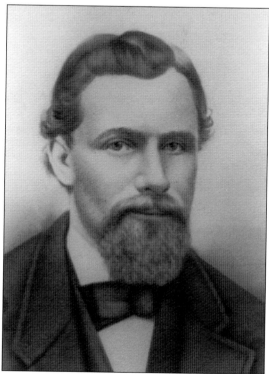

NIKLAUS MAURER. Born in Brügg, Aargau, in September 1844, Niklaus (Nicholas) was a breeder of Ayrshire cattle, an auctioneer, and owner of the Woodside Dairy Farm in Brookfield. He married Theresa Klatt. Tragically, he was killed by an automobile in 1907. His father, Niklaus Sr., a wheelwright and cheese maker, was born in Canton Bern on March 19, 1815. He died in 1892. His mother, Elizabeth, immigrated in 1847 and moved to Brookfield the same year. (Courtesy of Betty Peters.)

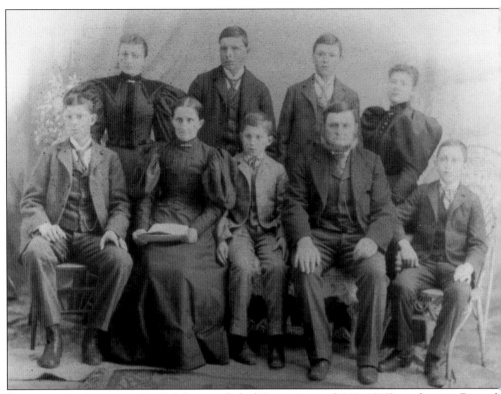

BAUMGÄRTNER FAMILY, C. 1895. Johannes (John) Baumgärtner (1843–1907) was born in Bittwyl Bern, where his family had lived for 500 years. He immigrated with his wife, Elizabeth Bürri and their five children in 1880. Pictured from left to right are (first row) Fred, Grandma, Nick Grandpa Samuel, and Edward; (second row) Mary, John, Ernest, and Elizabeth. Samuel, who was born in Bittwyl in November 1807, died in April 1892. (Courtesy of Jean Moyer.)

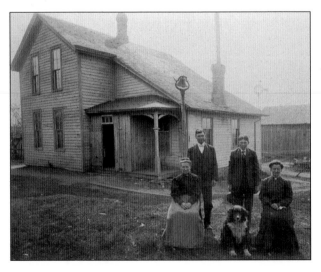

FAMILY FARM, 1910. John Baumgärtner was the proprietor of Woodside farm and a livestock breeder. Ernst Baumgärtner, his sister Mary (Baumgärtner) Kessler, George Bürri (cousin), and neighbor Minnie Kind are pictured here. The 80-acre farm in Section 14 in Waukesha was declared a Century Farm in 1980. Three generations owned the property. The last family owners were Russell Moyer and his wife, Jean Baumgärtner, John and Elizabeth's granddaughter. They were still using the original barn. (Courtesy of Gerald Gygax.)

THURGAUER. Christian Ochsner was born on August 3, 1803, in Wagenhausen and died in Brookfield on September 10, 1856. His wife, Elisabeth (Egg) Ochsner, was born on August 16, 1817. They were buried in the German Evangelical Cemetery in Brookfield, their grave marked by this stone. Christian's son Friedrich, from his first marriage, came to America with them in 1849. He married Margartha Wirz on April 6, 1861. (Photograph by Maralyn A. Wellauer-Lenius.)

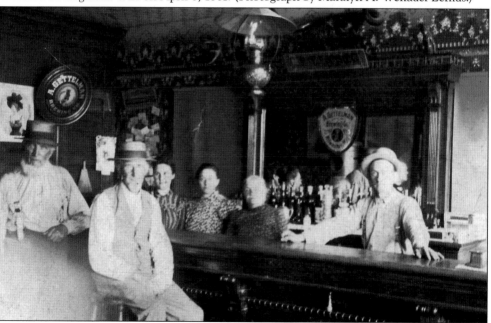

ELM GROVE HOTEL, 1915. This was a popular stagecoach stop on the Watertown Plank Road between Brookfield and Milwaukee. Later known as the Elm Grove Hotel, it was built in 1855. Owners Theodore Reusch and his wife, Bertha, are seen behind the bar. She was the daughter of Friedrich and Elisabeth (Ochsner) Schmutz. Brothers Friedrich, Christian, and John Schmutz immigrated to Brookfield from Interlaken, Bern, in 1849. (Courtesy of Thomas Ramstack.)

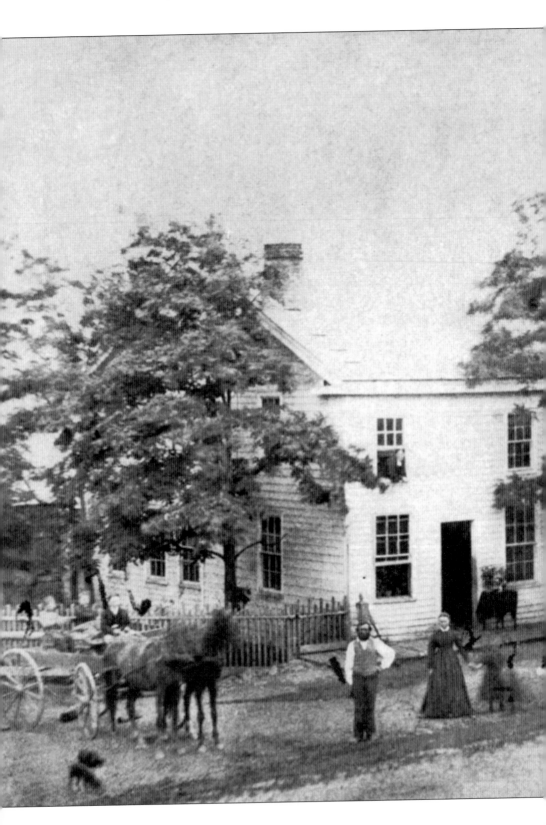

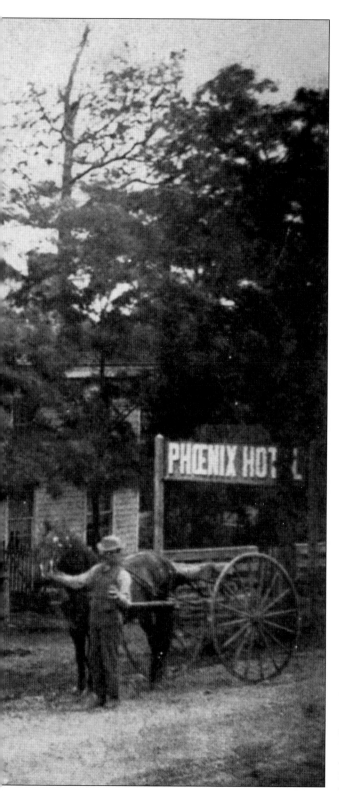

PHOENIX HOUSE. John Hoffmann (1819–1878) and his new bride, Anna Wellauer (1825–1896), were married in Wagenhausen, Thurgau, on April 12, 1849, just a few weeks before they boarded a ship for New York at Le Havre. They landed on July 2, 1849. They said the fireworks they heard two days later frightened them. The Hoffmanns settled in Brookfield after a short stay in Brooklyn, New York, where the young husband worked on a canal. The Hoffmanns were proprietors of the Phoenix House, pictured here, a popular rest stop for travelers between Waukesha and Milwaukee. They offered beds, board, and home-cooked German and Swiss meals. Free lunches were served with beer and whiskey. The spacious inn had a full-sized dance hall on the second floor and a large wainscoted dining room. A cheese room, bake oven, smokehouse, and vegetable and flower gardens were on the premises. After John's death in 1878, Anna (seen here leaning out of a second-story window) continued to run the inn with her children for almost 15 more years. John Hoffman is seen here in the white shirt, hand on hip. Other family members in view are Sophia, Ida, Eliza, Caroline, John (uncle) driving horses, Ferdinand, and Henry. (Photograph donated by Esther Mueller, courtesy of John M. Schoenknecht.)

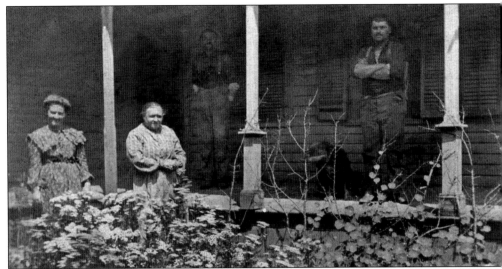

FARMING IN BROOKFIELD. Three generations of Wellauer men farmed in Brookfield. Rudolph returned to his farm on Elm Grove Road after his wife's death and a short stay in Milwaukee. He lived there with his son Heinrich Conrad (b. June 8, 1840, in Wagenhausen) until his death in 1894. H. Conrad died in 1899, and his Danish-born wife, Elise (Plett) Wellauer, stayed on the farm until her death in 1911. Mother Elise, her sons Edward and Conrad (arms folded) and Conrad's wife, Agnes (far left), are posed in front of their house. (Author's collection.)

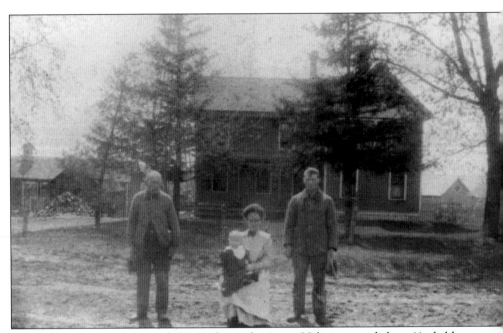

GYGAX FARM. Johann Samuel Gygax, his wife, Anna Uebersax, and their 11 children came to Waukesha from Seeberg, Bern, in 1881. They stayed with his sister, Marianna, wife of Rev. Fred Kuenzler (whose parents were Swiss) before moving to their farm on Genesee Road. This photograph was taken on Sam Gygax's farm on Highway 59, Waukesha. Samuel (1877–1959), baby Roy, Elsie Gygax, and Otto are in the photograph. (Courtesy of Gerald Gygax.)

THE WINZENRIEDS. Benedikt Winzenried and his Bavarian wife, Anna Kunigunde Ramstack, are photographed with their only daughter, Julia Ann. Benedikt, a carpenter 5 feet tall, was born in Belp, Bern, on November 25, 1831, and died on May 19, 1914. He and his three brothers all owned farms in Section 32 in the town of Brookfield. Anna died on December 27, 1870, when she was just 32 years old. (Courtesy of Elaine Moss.)

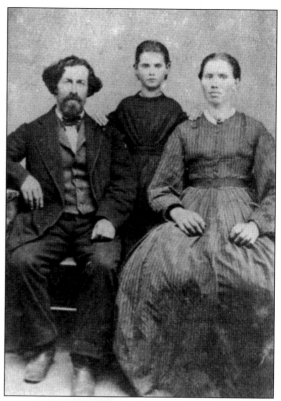

PIONEER. This well-aged gravestone in Pioneer Cemetery in Brookfield marks the resting place of patriarch Christian Winzenried. A carpenter, 4 feet, 11 inches tall, he was born in Gerzensee, Bern, on August 13, 1797, the son of Benedikt and Barbara (Speiker) Winzenried. In 1828, he married Susanna Catharina Marti in Belp. They immigrated with their children— Christian, Benedikt, and Magdalena—on September 22, 1857, and settled in Brookfield township. (Courtesy of Elaine Moss.)

Hauswirth

Saanen

Emanuel Friedli,
»Bärndütsch«
Saanen

HAUSWIRTH WAPPEN. Above is the armorial of the Hauswirth family of Saanen, Bern, the birthplace of Rudolf (b. 1806) and Katharina (Romang) (b. 1807) Hauswirth. They came to New Berlin, Waukesha County, with their seven children—Catherine, Maria, Christian, Emanuel, Magdalena, Marianna, and Simon—in July 1855. Rudolf filed his declaration to become a United States citizen in 1858. Their daughter Mary married Milwaukee alderman John Bächler, and Marianna married Rudolph Kuenzli. (Author's collection.)

COL. SIMON HAUSWIRTH (1845–1935) Hauswirth, son of Rudolf and Katherin (Romang) Hauswirth, was born in Saanen, Bern. In 1855, he came with his family to Brookfield, where they bought a farm. He enlisted in the Union Army in December 1863. He returned to the farm after his discharge and married Mary Deck in 1868. In 1870, they moved to Butte, Montana. There he was a member of the first city council and became city marshal. (Courtesy of the Montana Historical Society Research Center.)

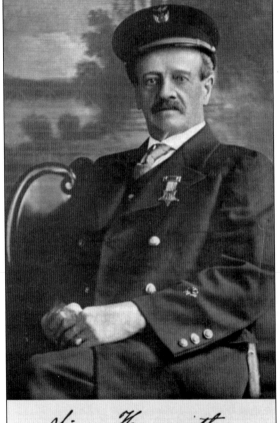

Simon Hauswirth

JAKOB HÄNGGI. Jakob, son of Urs and Magdalena Hänggi, was born March 11, 1813, in Nunningen, Solothurn. He sailed on the *Plato*, which landed in New York on October 17, 1833. He and his wife, Catharina Schlaraff, spent nine years in New York and Pennsylvania before settling in Waukesha County in 1842. Jakob moved to Holden, Missouri, in 1870 and died there in April 1900. Jakob's portrait was painted by Curt Frankstein. (Courtesy of Dr. Cecil and Clemency Coggins.)

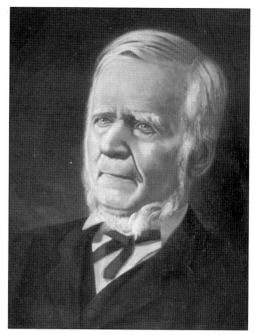

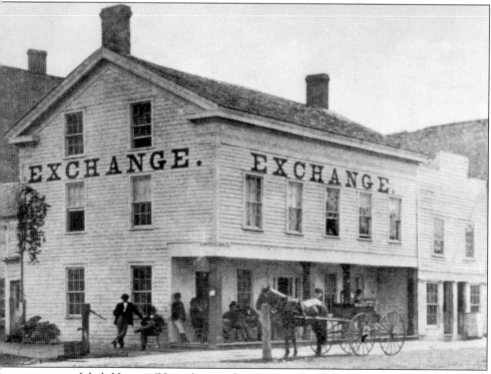

ENTREPRENEUR. Jakob Hänggi (Hengy) arrived in Prairieville (later Waukesha) with 50¢ in his pocket. He managed to establish a tailoring shop in a rough shanty and built Hengy's Exchange Hotel on the southwest corner of Main Street and Grand Avenue around 1845. He sold the hotel to P. N. Cushman, who sold it in 1864 to Frank M. Putney, namesake of the Putney block. It was razed in 1891. (Courtesy of the Waukesha County Historical Society and Museum.)

TERRITORY OF WISCONSIN,
Waukesha County, ss.

Sebastian Schlaraff personally appeared before the subscriber, the Clerk of the District Court of the United States for said County, being a Court of Record, and made oath that he was born in *Switzerland canton of*

on or about the year *eighteen* hundred and *twenty five* that he emigrated to the United States, and landed at the port of *New York* on or about the month of *September* in the year eighteen hundred and *thirty three* that it is bona=fide his intention to become a Citizen of the United States, and to renounce forever all allegiance and fidelity to any foreign Prince, Potentate, State or Sovereignty whatever, and particularly to *the republic of Switzerland.* whereof he is a ~~subject~~ *citizen*

Subscribed and sworn to the *Sixth* day of *April* A. D. 1847 *Sebastian Schlaraff*

Geo S West Clerk.

DECLARATION. The Schlaraff family left Switzerland on May 23, 1833, and arrived in the United States on July 26. Sebastian, born in 1825 in Kleinlützel, Solothurn, filed his intent to become a citizen shortly after he came to Waukesha County years later. The previous day, another Swiss, Jacob Kunta (Kunti) also filed. He was born in 1799 and immigrated in August 1832. (Courtesy of the Waukesha County Historical Society and Museum.)

LITERARY LIGHT. Historian J. H. Lacher called Jacob Spycher (1814–1891) "a literary light among the Swiss of this country." An intellectual from Oberbalm, Bern, Spycher gained recognition championing the Wilhelm Tell tale and writing for the *Schweizer-Zeitung*. He and wife, Anna Hänni from Zimmerwald, were passengers on the *Mortimer Livingston* in 1850, its passenger list shown at left. He purchased a 40-acre farm in Brookfield. By 1863, he was in Milwaukee making the first self-grown wine. Spycher was assessor, clerk, and treasurer of the school board. (Author's collection.)

KUNTZ'S MILL. Henry Kuntz (Kunz in Switzerland) (1806–1895), born in Wald, Zürich, and his German-born wife, Phoebe (Philippena) Graf, arrived in Merton in 1841. A skilled architect in Switzerland, Kunz built a house, sawmill, and gristmill. This development was known as Kuntz's (Kunz's) Mill, later renamed Monches Mill, and was eventually known as Monches. Kunz operated his mill until 1869 and retired to Brookfield. (Courtesy of Scott R. Sieckman and Matthias Kastell.)

KUNTZ HOUSE. Henry Kuntz, intrigued by reports of gold discoveries in California, sold his house in 1849 and was ready to join the miners. When the sale fell through, he reclaimed his house and property and never left. A fire damaged the original house and mill in 1977. The home was rebuilt and is a quiet rural bed and breakfast currently owned by Elaine Taylor. (Courtesy of Scott R. Sieckman and Matthias Kastell.)

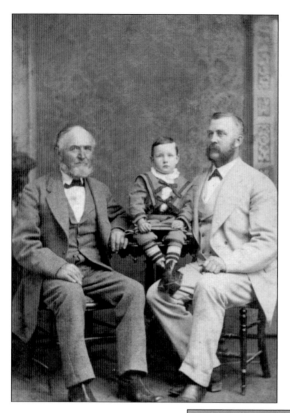

THE KUNTZES. Grandfather Henry Kuntz, his son Henry Kuntz Jr., and grandson Harry Kuntz sat for this three-generation photograph. Sadly, Harry died when he was only 11 years old. Henry Jr. and his wife, Jean Mitchell, had two other children, Edessa and William. They moved to Poynette (Columbia County), where Kuntz purchased a mill. He died there in 1911. (Courtesy of Scott R. Sieckman and Matthias Kastell.)

ST. PAUL'S UNITED CHURCH OF CHRIST. Shoemaker Fred Heel, Carl Baulder, and Emil Henry Brunner were Swiss living in Menomonee Falls. Brunner was "one of the established businessmen" there, according to Theron Haight in his *Memoirs of Waukesha County* (1907). The names of these men and other Swiss, including Dennler, Hatz, and Amweg, appear in the registers of St. Paul's Church. (Courtesy of the Waukesha County Historical Society and Museum.)

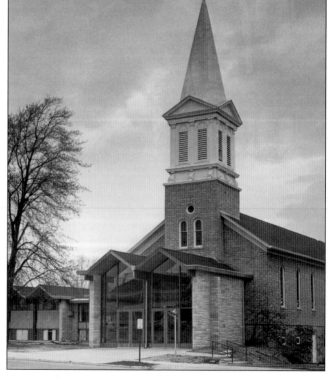

HOTELKEEPER AND CARPENTER IN MENOMONEE FALLS. Henry Wellauer, born on December 16, 1827, in Wagenhausen, Thurgau, immigrated in October 1848. He and his Swiss wife, Anna Peter (seen at right), were hotel keepers. They had four children, Paulina, Rudolf, Jacob, and Sophia. Benedicht Kuepfer, a carpenter, immigrated to Milwaukee in 1853. A few years later, he bought a farm in Menomonee Falls, where he stayed until his death in 1874. (Courtesy of Mary K. Reddy.)

CORPORAL GROB IN 1892. Heinrich Grob was born on September 16, 1841, in Rossau, Zürich, the son of Heinrich and Regula Grob. The family settled in Brookfield in 1854. Heinrich enlisted in the Sigel Guards. He married Ernestine Marth in 1867 in Cedarburg, Ozaukee County, and afterward they moved to Marathon County. He died in 1914 in Wausau and is buried there. (Courtesy of Kent A. Peterson.)

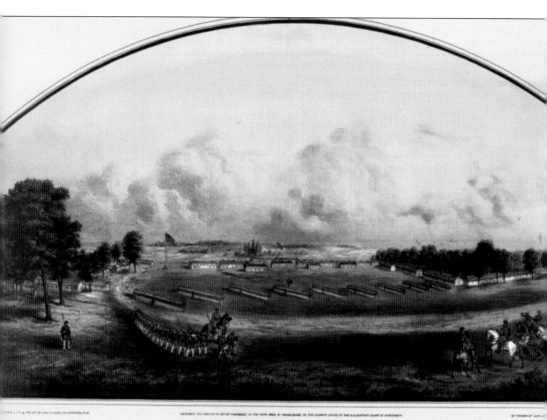

CAMP WASHBURN, MILWAUKEE, WIS.
TAKEN FROM THE SOUTH SIDE.

TRAINING CAMP. Many young recruits from Waukesha County received basic training at Camp Washburn. One of them, Henry Grob, wrote, "We were drilled in Camp Washburn near Milwaukee, was laid up for 6 weeks in the hospital with Typhoid fever, was offered a discharged [sic] but refused it." This rare image was captured by photographer Louis Kunz. The following Waukesha County Swiss men served in the Civil War: Henry Grob (Brookfield, corporal, Company H, 28th Wisconsin Volunteer Infantry); John Hasler (Brookfield, private, Company B, 28th Regiment, Wisconsin Infantry); Joseph Hengy (Brookfield, private, Company K, 28th Regiment, Wisconsin Infantry); Matthias Holzer (Delafield, private, 28th Regiment, Wisconsin Infantry); Nicholas Holzer (Delafield, 28th Regiment, Wisconsin Infantry); Simon Hauswirth (Brookfield, private, Company C, 35th Regiment, Wisconsin Infantry); William Sinclair Hengy (sergeant, Company B, 36th regiment, Wisconsin Infantry); Carl (Charles) Ries (Brookfield, private, Company I, 43rd Wisconsin Infantry (24th Regiment Wisconsin); Godfrey Ries (Brookfield); Nicholas Ries (Brookfield, Company B, 9th Wisconsin Infantry); and John Schmutz (Brookfield, private, Company H, 48th Wisconsin Infantry). (Courtesy of the Library of Congress, LC-USZ62-16004.)

Seven

SWISS IN WASHINGTON AND OZAUKEE COUNTIES

WAYNE COUNTY PLAT, 1892.
By 1850, German and Swiss immigrants were replacing the earlier Irish settlers of Washington County. Names of many Swiss families who settled first in nearby Fond du Lac County could be found on plat maps throughout the area. In successive generations, they spread out into Washington County on farms and in towns. Washington County had a uniquely Swiss community, Mayfield. Andreas Riederer platted the small community in the county in 1852 and named it after his hometown, Maienfeld in Graubünden. He operated a small sawmill on Cedar Creek. Mayfield's first postmaster, John Toedly, was also Swiss. (Reproduction from the Collection of the Washington County Historical Society.)

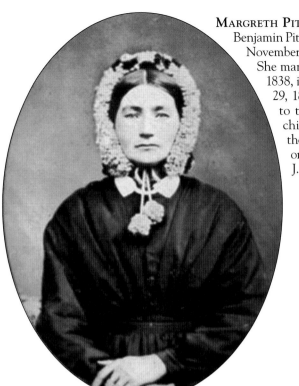

MARGRETH PITSCHI. Margreth was the daughter of Benjamin Pitschi and Barbara Jann. She was born on November 5, 1820, in St. Antonien, Graubünden. She married Hans Rudolf Jäcklin on April 21, 1838, in Schiers. Rudolf was born on January 29, 1815, in nearby Schuders. They came to the town of Polk in 1847 with their children. Rudolf died on July 27, 1862, in the town of Polk, and Margreth died there on February 7, 1883. (Courtesy of Stephen J. Gruber.)

JOHANN PETER RIESCH. Riesch was born on July 2, 1827, in Maienfeld, Graubünden. He immigrated in 1855 and settled on a 40-acre farm on Highway 33 in West Bend. He married Magdalena Barbara Jäcklin in West Bend on October 20, 1858. She was born in Schiers on July 20, 1840. After their marriage, they removed to a farm on Cedar Lake. They had nine children. (Courtesy of Stephen J. Gruber.)

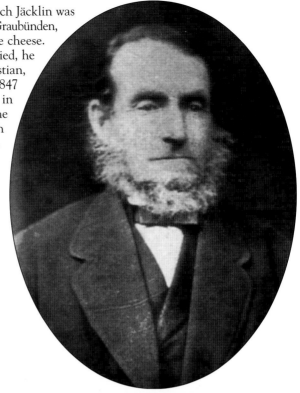

ALPINE CATTLE HERDER. Johann Ulrich Jäcklin was born on December 13, 1801, in Schiers, Graubünden, where he worked with cows and made cheese. When his wife, Margaretha Friedli, died, he brought his three sons, Rudolph, Christian, and Lucius (Lewis), to America in 1847 onboard the ship *Huron*. They landed in New Orleans and made their way up the Mississippi River to Wisconsin. Ulrich died November 10, 1874, in West Bend. (Courtesy of Stephen J. Gruber.)

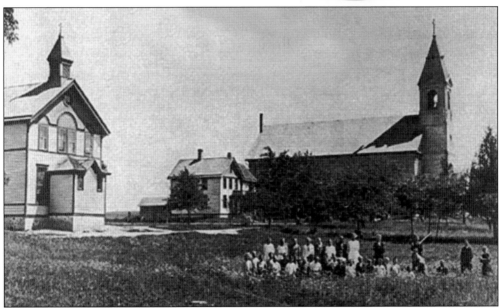

REV. JOHN BELLINGER. Born March 29, 1836, in Dietikon, Zürich, and ordained on March 21, 1860, Bellinger immigrated to New York on May 1, 1870. He was pastor at St. Boniface Catholic Church in Goldenthal from 1878 to 1880. Afterward, a parsonage and school were erected on the site. Goldenthal later became Goldendale, which was merged into the village of Germantown in 1964. (Reproduction from the Collection of the Washington County Historical Society.)

SITE OF FIRST BIERI CHEESE FACTORY.
Hans (John) Bieri immigrated in 1919
from Bern and sent for his future bride,
Frieda, a year later. After their marriage
in Hartford, they operated a cheese
factory in Woodland (Dodge County),
and in 1945, started the Polk Dairy
Cheese Factory on Mayfield Road.
Washington County was once a haven
for Swiss cheese makers. The Bieris were
famous for hosting Swiss gatherings
on Sunday afternoons. (Reproduction
from the Collection of the Washington
County Historical Society.)

**THE LAST FAMILY CHEESE FACTORY
IN WASHINGTON COUNTY.** The Bieris
built a retail outlet on Highway 45 in
Jackson, the main north-south route
from Milwaukee. The old couple
tended the factory store until the
mid-1970s, when they turned over
the business to their sons, John and
Reinhold Bieri. They made cheese
the old European way—cutting and
wrapping their products by hand.
Reinhold Bieri received the Governor's
Award in 1968. (Reproduction from
the Collection of the Washington
County Historical Society.)

HANS (JOHN) KOBELT (1850–1924). Kobelt had two barns and a sturdy stone house on his property, located on Scenic Drive, 1 mile south of Highway 33. This photograph, taken by the north barn, shows his friend August Richter (right), a harness maker. Kobelt, a successful horse dealer (left), was one of several Swiss in the area who owned large farms. (Reproduction from the Collection of the Washington County Historical Society.)

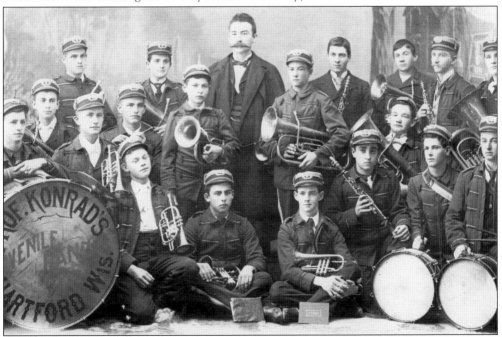

ZUEST. Johannes Zuest (1851–1920) poses to the right of the conductor of Professor Konrad's Juvenile Band. Later John was a musician in the Spanish-American War (4th regiment, Company G, Milwaukee). He was born in Wolfhalden, Switzerland, and immigrated in February 1852. He married Lena Rusioni on July 29, 1877, and they had six children—John, Barbara, Conrad, Lena, Emma, and Mrs. John Hollenstein. (Reproduction from the Collection of the Washington County Historical Society.)

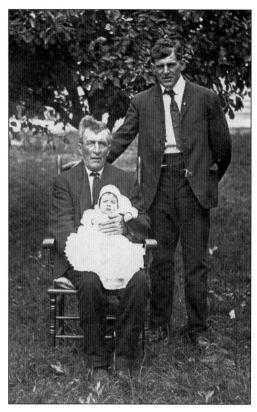

THREE GENERATIONS. This family group portrait in 1910 shows Ulrich Huber III (seated), cofounder of the Germantown State Bank. After his death in 1924, his son Ulrich Huber IV served on the bank's board. The baby is Ulrich Huber V. Five generations farmed 160 acres on Maple Road in Germantown and marketed their butter, eggs, and fruit in Milwaukee until the 1940s. The family originated in Dietingen, Thurgau, and immigrated in 1855. (Courtesy of Marge Miller.)

ZION'S EVANGELICAL LUTHERAN CHURCH. Several Swiss worshipped alongside German-speaking families from Brandenburg, Mecklenburg-Schwerin, Pomerania, Posen, Wuerttemberg, among other areas in Prussia and Bavaria, inside this Hartford church. These were families Dreger (Splügen), Hosig (Nuferen), Liver (Sarn), Mengelt (Splügen), Riedhauser (Zillis), and Zuest (Chur) from Graubünden; and from Bern, families Roemer, Schneider, Winkler, Wittenwyler, and Zimmermann. (Reproduction from the Collection of the Washington County Historical Society.)

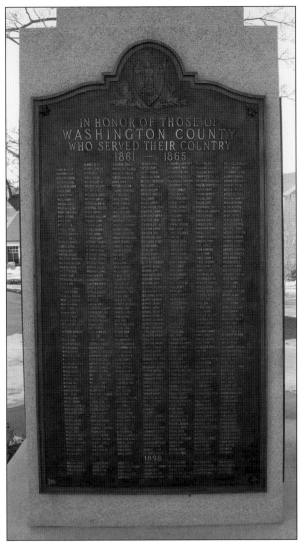

MEMORIAL, 1861–1865. This simple monument contains the names of men who served their country during the American Civil War. It was erected in front of the old Washington County courthouse in West Bend. The plaque includes the names of the following Swiss: Fridolin Elmer (Washington, 46th Infantry, Company G); John Engler (Trenton, Hancocks Corps); Adam Hefty (Washington, 46th Infantry, Company A); Rudolph Kaderly (Washington, 9th Infantry, Company H); Thomas Klassy (Washington, 31st Infantry, Company F); William Klassy (Schlesingerville, 9th Infantry, Company C); William H. Landolt (Port Washington, 5th Regiment, Company C); George Mengelt (Hartford, 9th Infantry, Company G); Ulrich Rothenberger (Wayne, 50th Infantry, Company F); Joseph Schaub (Newburg, 9th Infantry, Company I); Christian Schwendner (Wayne, 12th Infantry, Company D); John S. Schwendener (Wayne, 12th Infantry, Company D); Andrew Senn (West Bend, 12th Infantry, Company D); Thomas Streiff (Germantown, 46th Infantry, Company A); Peter Tarnutzer (Jackson, 7th Infantry, Company K); Andrew Tischhauser (Farmington, 7th Infantry, Company K); Charles Utz (Kewaskum, 9th Infantry, Company K); Joseph Utz (West Bend, 9th Infantry, Company K); Xavier Utz (Trenton, 7th Infantry, Company E); Samuel Winzenried (Washington, 31st Infantry, Company C); and Jacob Zweifel (Washington, 46th Infantry, Company A). (Photograph by Maralyn A. Wellauer-Lenius.)

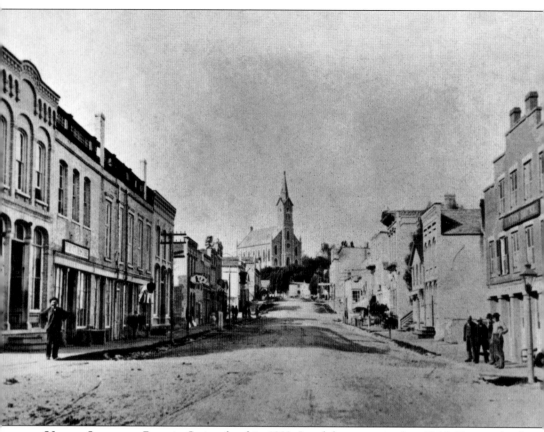

ULRICH LANDOLT. Born in Switzerland in 1822, Landolt immigrated in 1846. He was the first school trustee in Belgium and farmed there until 1853, when he moved to Port Washington. He served as deputy county treasurer and became treasurer for two terms. From 1866 to 1875, he operated a flour and feed business. Gottlieb Biedermann, a Swiss from Thalwil, Zürich, and his wife, Elizabeth Bickel, also settled in Port Washington. (Courtesy of the Wisconsin Historical Society.)

Eight

SWISS SOCIETIES

Aug 17, 1913.

SWISS SOCIETIES PICNIC. Members of the Swiss clubs and their families met in fellowship for about two decades in a grove on Jacob Wellauer's farm in Wauwatosa. This photograph was taken at their annual picnic in 1913. In an interview in 1970, Jacob's daughter Anna recalled that she and the other children were allowed to taste the early, sweet wine—*Suser* in *Schwyzerdütsch* (Swiss-German)—made by the Swiss, and they considered it quite a treat. Jacob built a specially designed outdoor pavilion to accommodate performances by the yodelers and bell ringers. (Courtesy Mary K. Reddy.)

SCHWEIZER MÄNNERCHOR, 1912. The new Swiss Male Chorus, chartered on October 18, 1879, was an offshoot of Milwaukee's Swiss Club. The group was directed by a non-Swiss, Joseph Benedict, for many years. About two dozen talented singers spent many hours rehearsing with a piano donated by fellow club member Jacob Wellauer. The stouthearted singers struggled to raise enough money to travel to out-of-town *Sängerfests* like this one in nearby Chicago. (Courtesy of Fred Roethlisberger.)

FIFTIETH ANNIVERSARY. The *Schweizer Männerchor* celebrated its 50th anniversary on May 19, 1929, with a gala celebration, a concert held at 2527 Juneau Avenue, and a photograph. At the time, there were 50 active, 12 honorary, and over 100 passive members. They met at Luethy's, Schneeberger's, and Schaufelberger's, restaurants and taverns. The *Schweizer Männerchor's* first flag, made by Mrs. Albert Spörri and Katherine Maurer, was dedicated in 1890. (Courtesy of Anita Gamma.)

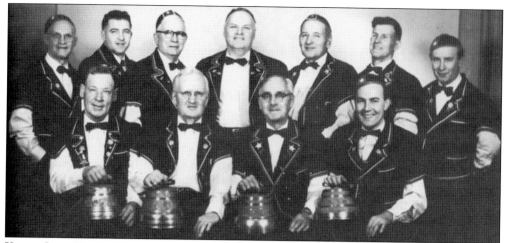

YODEL CLUB *HEIMATKLÄNGE*, MILWAUKEE. This group photograph of talented entertainers and Swiss Club members was taken in the 1950s. The Yodel Club members shown are, from left to right, (first row) Franz X. Buchholz, Joseph Gamma, Otto Flaig, and Albert Hardegger; (second row) Herman Mueller, Willy Staufiger, Hans Zimmerman, Jack Hubacher, Gottfried Feller, Ernst Straubhaar, and Paul Iff. (Author's collection.)

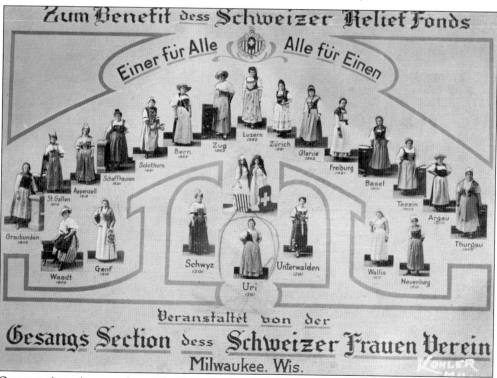

ONE FOR ALL, ALL FOR ONE. The Swiss Ladies Society singers hosted an event on October 28, 1916, to benefit victims of the war in Europe. Various cantonal costumes (*Trachten*) are depicted in this photograph. In June 1927, some 17 ladies gathered together to sing the songs of their homeland and formed the *Schweizer Damenchor* (Swiss Ladies Chorus). They won first prize at the 1939 *Sängerfest* in Pittsburgh, Pennsylvania. (Courtesy of Anita Gamma.)

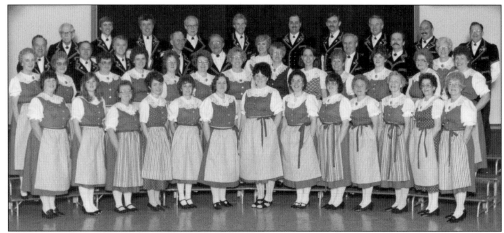

SWISS SINGING SOCIETY OF MILWAUKEE, 1985. The Swiss Male Chorus and the Swiss Ladies Chorus joined together in January 1983 to form the Swiss Singing Society of Milwaukee. Their first director was Nancy McKinley Ehlinger (center of first row). Members of the group today are Swiss-born, are married to a Swiss, or are Americans of Swiss descent. They perform at Swiss social functions each year, at schools, nursing homes, and churches. (Courtesy of Bert Langenegger.)

APPENZELLERIN. Mary (Kellenberger) Kunzler is shown here offering a beer and a good time to someone just arriving at a Swiss picnic in Heidelberg Park around 1960. She and her husband, Hans Kunzler, lived on North Twelfth Street in Milwaukee. Kunzler was the very active president of the Swiss Ladies Society for over 30 years. She was born in Rhatobel, Appenzell, in 1901. (Courtesy of Carl Kunzler.)

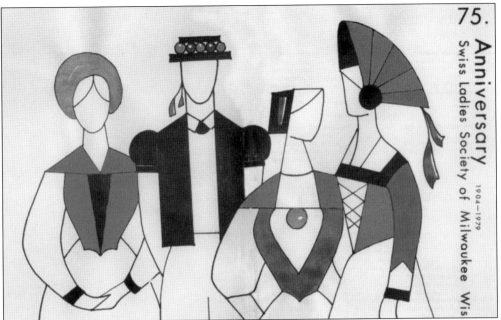

SEVENTY-FIVE YEARS (1904–1979). The Swiss Ladies Society of Milwaukee celebrated its 75th anniversary in 1979 with a gala celebration. Nell Weidmann designed the program, menu cards, and table decorations for the event. The Swiss consul and Mildred Roschi, the Swiss Ladies Society president, were in attendance. Doris Geiger, Irène Neff, and Emmely Ralph organized a colorful fashion show, which featured about 20 authentic Swiss costumes. (Courtesy of Nell Weidmann.)

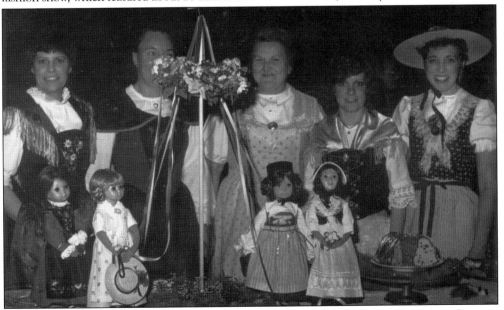

ARTIST SERIES. From left to right, Irène Neff, Doris Geiger, Nelly Weidmann, Rose Ann Gamma, and Emmely Gideon proudly display an abundant buffet of Swiss desserts, skillfully prepared by members of the Swiss Ladies Society. The bounty was served to patrons and donors following a concert by the renowned Swiss tenor Ernst Haefliger, who performed at the Pabst Theater on March 22, 1983. (Courtesy of Nell Weidmann.)

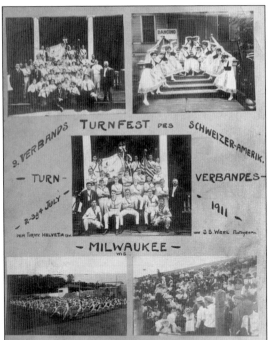

TURNFEST MILWAUKEE. The Pabst Park Hall, on Third and Garfield Streets, was designated the new place to train in January 1908, and on July 2–4, 1911, the Swiss Turners hosted the Ninth Swiss American *Turnfest* Milwaukee on the site. The group flourished prior to World War I, but the conflict brought activities to a standstill. Many of the young Swiss men were away serving their country. (Author's collection.)

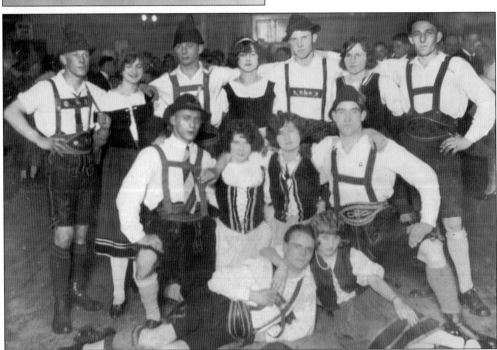

CLOWNING. The Turners suspended gym classes until 1924. Identified in this 1929 photograph are Ernest Bummer (first row), Max Raeber (third row, third from left), Hans Birk (third row, right), and Engelbert Britt. After the war and stock market crash (1929), it was difficult to keep the society together. New immigrants Albert Ciocarelli, Lawrence Egger, Joseph Gamma, Max Raeber, Bill Roth, and Ferd Roethlisberger infused new vitality into the group. (Courtesy of Ray Ciocarelli.)

MIXED TURNERS, 1920s. Old-timers recall that members were joyful in July 1937, when they were finally able to send a group of 12 men to Monroe, Wisconsin, to compete in their first national meet as a team since Milwaukee hosted the event in 1911. The group finished third in a field of 11 teams from all over the country. Children's classes were added in September 1937. (Courtesy of Ray Ciocarelli.)

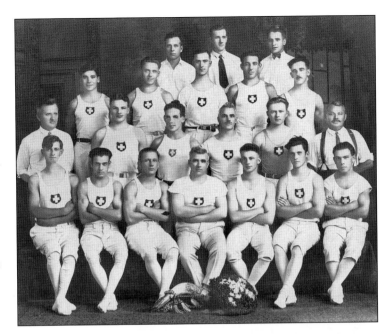

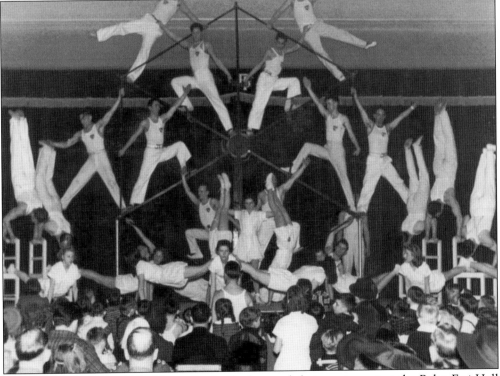

OCTAGON TURNERS, 1939. After a fire badly damaged their equipment at the Bahn Frei Hall on Twelfth Street and North Avenue, the Turners moved their activities to the fourth floor of the North Avenue Auditorium at Thirty-first Street and North Avenue. They held meetings at the Swiss Club, 2435 West Vliet Street, while gym classes were conducted at the North Avenue Auditorium. It became a strong coeducational group. (Courtesy of Fred Roethlisberger.)

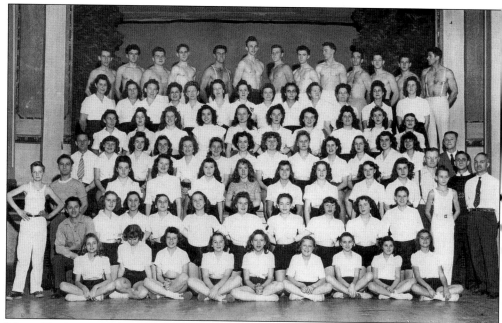

MIXED TURNERS, 1940S. Gymnasts in this photograph include Ernie and Ellen Straubhaar; John Knuesel; Ernie and Sonya Dallapiazza; Dick Schwartz; Eugene, Max, and Lillian Raeber; Dr. Frank Ohm; John Knuesel Jr.; Joe and Louise Zipp; Josephine Ciocarelli; Flora Birk; Ferdie and Emma Roethlisberger; Charlie Fischer; Evelyn Iff; Ralph Quosig; and Sylvia Kunzler. Twenty-two men and one woman, members of the Swiss Club, served in World War II. John Knuesel Jr. and Ralph Striewe died in France. (Courtesy of Ray Ciocarelli.)

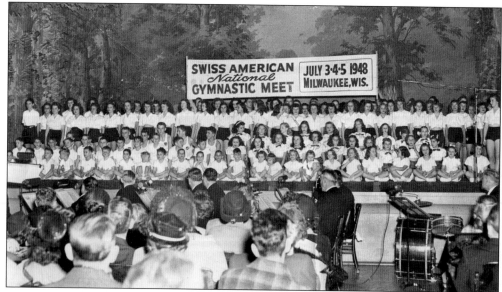

SWISS AMERICAN NATIONAL GYMNASTICS MEET. Back in action after World War II, the Swiss Turners hosted the National *Turnfest* on July 3–5, 1948. It was the first time the event had been held in Milwaukee since 1911. Milwaukee men took fifth place in the team competition, and the women placed third. In 1956, the Turners sponsored the Swiss National Olympic Team, which toured the United States. (Courtesy of Ray Ciocarelli.)

Star. Fred Roethlisberger, Ferd's son, competed in World Games in Dortmund in 1966 and was on the U.S. team at the Pan-American Games (1967). Fred was a member of the 1968 U.S. Olympic gymnastic team in Mexico City. Fred was chosen as the University of Wisconsin-Madison's most valuable athlete, the athlete of the year, and the top Big Ten gymnast. Roethlisberger was born in Milwaukee on February 23, 1943. He was elected to the Wisconsin Athletic Hall of Fame in 1990. (Photograph by Maralyn A. Wellauer-Lenius.)

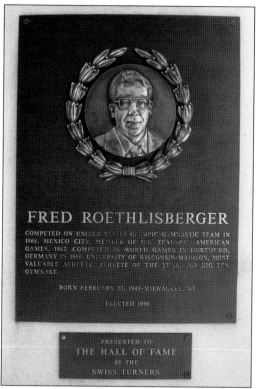

FRED ROETHLISBERGER

COMPETED ON UNITED STATES OLYMPIC GYMNASTIC TEAM IN 1968, MEXICO CITY. MEMBER OF U.S. TEAM-PAN AMERICAN GAMES, 1967. COMPETED IN WORLD GAMES IN DORTMUND, GERMANY IN 1966. UNIVERSITY OF WISCONSIN-MADISON, MOST VALUABLE ATHLETE, ATHLETE OF THE YEAR, TOP BIG TEN GYMNAST.

BORN FEBRUARY 23, 1943-MILWAUKEE, WI

ELECTED 1990

PRESENTED TO
THE HALL OF FAME
BY THE
SWISS TURNERS

Swiss Turnverein "Helvetia." After operating out of St. Aloysious's gymnasium for 11 years, the Turners moved into their own facility. The chalet-like Swiss Turners Gymnastics Academy, nestled into a quiet setting at 2214 South 116 Street, is their current location. It is the largest gymnastic training facility in Wisconsin (12,000 square feet). Willy Staufiger brought the fir tree growing in the front of the building from Switzerland. (Photograph by Maralyn A. Wellauer-Lenius.)

NORTH AMERICAN SWISS ALLIANCE. The NASA, a fraternal benefit organization founded in 1865, was incorporated in Ohio in 1889. The Milwaukee branch started as the *Grütli Bund* of North America on February 23, 1873. The NASA is still actively committed to fostering the continuation of Swiss values and traditions in the United States and publishes a quarterly newspaper, the *Swiss American*. (Courtesy of Carl Kunzler.)

CITY OF FESTIVALS PARADE (1983–1994). This colorful event opened Milwaukee's festival season and showcased the ethnic festivals held along the shores of Lake Michigan. Irène Neff, parade director and native of Canton Uri, organized unique units from around the world to participate. Switzerland was represented, in various years, by elaborately costumed Mardi Gras units, namely the *Röllelibutzen Verein*, Altstätten; *Borggeischter Musik*, Rothenburg; *Musikgesellschaft Konkordia*, Widnau; and the prestigious marching band, *Musikgesellschaft Ostermundigen*. (Author's collection.)

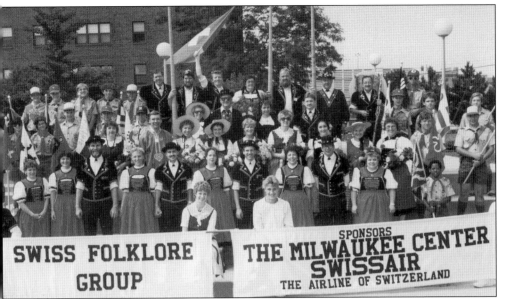

SWISS FOLKLORE GROUP, 1987. Two more groups engaged for the parade were Swissair Folklore Band/Group and the *Handharmonika Orchester*, both from Kloten, Zürich. This photograph is a composite of members of the Milwaukee Swiss community, including the Swiss Dancers of Milwaukee. Joining them are members of the Swiss Folklore Group from Zürich and the flag-bearers, Boy Scouts of America. (Courtesy of the Swiss Turners *"Helvetia."*)

ALPINE PARADE, 1992. Swiss gathered at Max Meier's Hartland Inn for a day of festivities. Pictured here from left to right are Shelia Geanneret, Ella Aeschbach, Joe Gamma Jr. (Wilhelm Tell), Vreni Roth, John Hahbegger, and Rose Ann Gamma. Joe Gamma was trustee of the Swiss-American Fraternal Society and recording secretary of the Swiss Turners. His father, Joseph Sr., born in Canton Uri in 1884, came to Milwaukee in the 1920s. (Courtesy of Margrit Meier.)

MEMORIES OF DAYS GONE BY. The former Swiss Club still stands in its faded glory at the corner of Twenty-fourth Place and Vliet Street. Older Swiss fondly remember meeting their spouses there. Others recall spirited parties, songfests, meetings, Friday fish fries, and the slot machines on the premises. After the club was sold, the *Männerchor* met at the International Institute on Highland Boulevard; the Turners met at Jefferson Hall. (Photograph by Maralyn A. Wellauer-Lenius.)

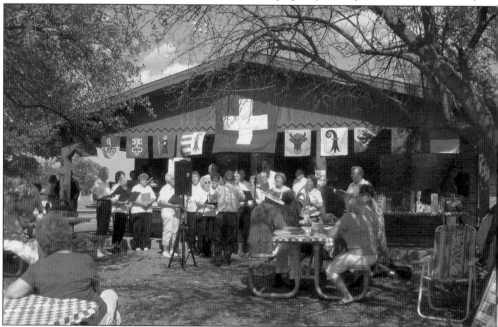

PICNIC, AUGUST 2, 2009. It was a sunny day when these Swiss families met at Frontier Park in Butler (adjacent to Milwaukee). Gatherings like this one, held annually on the first Sunday in August, commemorate Swiss Independence Day. The Swiss Singers entertained. Other collegial events held with regularity include the Valentine dinner dance in February, the November-*Feiertag*, and annual luncheons for the Swiss Ladies Society. (Photograph by Maralyn A. Wellauer-Lenius.)

120

Nine

CARRYING THE TORCH INTO THE 21ST CENTURY

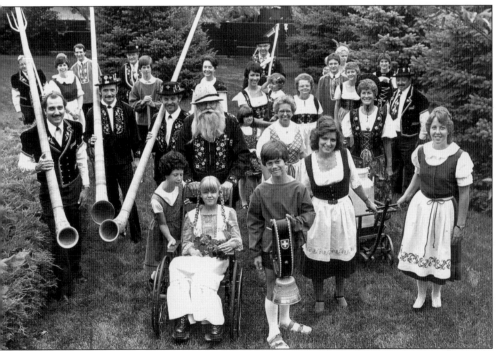

WITH ALPHORNS AND COW BELLS IN HAND. The Swiss were the featured ethnic group at the 38th annual Holiday Folk Fair, sponsored by the International Institute of Wisconsin. The event was held at the Milwaukee Mecca on November 20–22, 1981. Milwaukee's Swiss community joined together to present authentic folk art demonstrations, food and cultural exhibits, folk dancing, dinner, and entertainment. William Stamm, Milwaukee's fire chief, was cast in the role of grandfather in performances of the traditional Heidi story at the Folk Spectacle and the Young People's Matinee. Other cast members in the forefront are Sheri Callsen (Heidi), Kris Shoemaker (Klara in the wheelchair), and Ryan Neff (Goat Peter). Chief Stamm was president of the Swiss American Societies, Inc. (Courtesy of the International Institute of Wisconsin.)

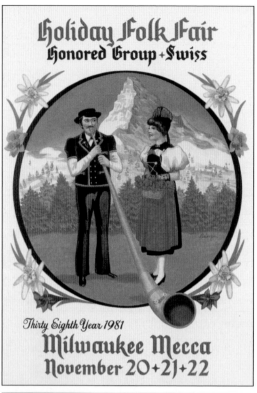

HONORED GROUP, 1981. Barney Brienza used veteran fair workers John and Carla (Staufiger) Buchel as models for this colorful program cover. The *Alp Chilbi* (Alpine Festival), a spring procession of shepherds and their cows to the mountain pastures, was featured in folk spectacle. Volunteers prepared and served Swiss delicacies such as *Öpfelchüchli* (apple fritters), *Schenkeli*, *Chnüblaetz*, *Rosechüchli*, *Brezeli*, *Leckerli*, and *Landjaeger* (smoked Swiss sausage) for the Sidewalk Café. (Author's collection.)

THE FAIR'S ORGANIZING COMMITTEE. This cheerful, enthusiastic group overlooking a planter full of traditional geraniums includes, from left to right, Doris Geiger, John Habegger, Irène Neff, Joseph Gamma Jr., and Madelyn Staufiger. Gamma, his wife, Agnes, and the Swiss Turners were in charge of the food booth, Geiger and Neff manned sales tables with help from members of the Swiss Ladies Society, and the Staufiger family assembled cultural exhibits. (Courtesy of the International Institute of Wisconsin.)

BIG HORN, LITTLE GIRL. David and Hilde Staufiger's daughter Laura got into the act when she was two years old. Wearing her Aunt Ellen's old costume, Laura shows her curiosity about this large alphorn, the national instrument of tourist Switzerland. David's family has been involved in the folk fair since 1956, only six years after his father, Willy, relocated from Bern. His maternal grandparents were from Canton Basel. (Courtesy of the International Institute of Wisconsin.)

DEMONSTRATION. The alphorn, which dates back to the middle of the 16th century, was originally used as a signaling instrument by herdsmen. Alphorns are usually more than 10 feet in length, with a range of no more than two octaves. The alphorn has no valves. Willy Staufiger and son-in-law John Buchel demonstrate technique in this photograph. Willy's daughter Ellen (far right) was Miss Holiday Folk Fair (1981) and official hostess. (Courtesy of the International Institute of Wisconsin.)

Papal Swiss Guard. Paul Good, native of Mels, St. Gallen, who currently resides in Waukesha County, was a member of the elite Papal Swiss Guard from 1949 until 1951. In this photograph, taken in 1950, he escorts an American party to an audience with Pope Pius XII. The guards protect the pope at the Vatican in Rome. He and fellow guard Walter Albert Hardegger came to Milwaukee early in 1952. (Courtesy of Paul Good.)

Check out our specialty desserts

To Oconomowoc · To Pewaukee
16 · 16
Hwy E
Cottonwood Avenue
Capital Drive
★ *Max Meier's Hartland Inn*

110 Cottonwood Avenue
Hartland, WI 53029
(262) 367-6800

What makes the Hartland Inn the choice for so many people...

"*The staff is so friendly and inviting...I'll keep coming back.*"
— LR, Oconomowoc

"*I love your Friday night seafood.*"
— KS, Hartland

"*Each visit here is a special night for us. We are treated like royalty.*"
— CC, Delafield

"*The best place in town this side of a striped tent.*"
— HQ, Chenequa

"*It's worth a trip from Milwaukee to enjoy the old-world cuisine and friendly ambience.*"
— GMC, Milwaukee & Oconomowoc Lake

Max Meier's

Hartland Inn

The House of Swiss Elegance
&
Gemütlichkeit

The Meiers. Margrit Sidler Meier, born in Cham, Zug, is featured in *Westwärts: Encounters with Swiss American Women* by Susann Bosshard-Kalin (2009). She came to the United States in 1964. Her future husband, Max Meier (1930–1998), had already left Zürich by 1951. They owned and operated the Hartland Inn in Hartland. Previously he was assistant chef at the University Club in Milwaukee and comanaged the Milwaukee Swiss Club with Albert Hardegger. (Courtesy of Margrit Meier.)

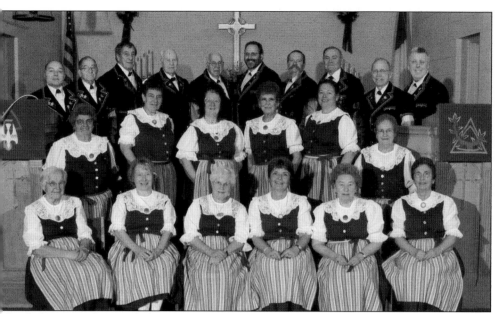

SWISS SINGERS, 2003. In June 2009, local singers were recognized by the North American Swiss Singing Alliance, an organization of choral groups from the Upper Midwest and Canada, for their many years of singing service. Madelyn and Willy Staufiger, Anita Callsen, Raymond Ciocarelli, Susan Mickschi, Catherine Kiener, Bert Langenegger, Peter Neuenschwander, Margaret Wickesberg, Hilbert Wiedenkeller, LoAnne Zentner, and Paul Good all received awards. The NASSA hosted *Sängerfests* in Milwaukee in 1947 and 1985. (Courtesy of Bert Langenegger.)

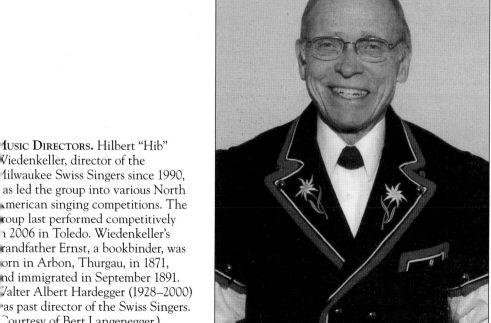

MUSIC DIRECTORS. Hilbert "Hib" Wiedenkeller, director of the Milwaukee Swiss Singers since 1990, has led the group into various North American singing competitions. The group last performed competitively in 2006 in Toledo. Wiedenkeller's grandfather Ernst, a bookbinder, was born in Arbon, Thurgau, in 1871, and immigrated in September 1891. Walter Albert Hardegger (1928–2000) was past director of the Swiss Singers. (Courtesy of Bert Langenegger.)

CHALET VRENELI. This beautiful, authentic chalet-style home in Brookfield was built entirely from Swiss plans in 1971 by William Roth, a native of St. Gallen, for his wife, Vreni (shown above). She has been involved in the Swiss community since her arrival in Milwaukee from Reutlingen, Zürich, in 1950. A well-known yodeler and entertainer in the Midwest, Vreni performed and recorded with accordionist Ernst Wicki and clarinetist Jörg Fürrer. (Courtesy of Vreni Roth.)

SWISS AMERICAN. Carl H. Kunzler, son of Hans and Marie (Kellenberger) Kunzler, is president of Anden Business Systems in Brookfield, Wisconsin. He is currently a member of the North American Swiss Alliance board. Carl and his wife, Dorothy, are seen here relaxing at the 2005 Holiday Folk Fair in Milwaukee. Both have been active in the Swiss community for many years and continue to attend picnics and other annual events. (Courtesy of Carl Kunzler.)

BIBLIOGRAPHY

ruce, William George. *History of Milwaukee City and County*. Chicago: S. J. Clarke Publishing Company, 1922.

ower, Frank A. *History of Milwaukee, Wisconsin*. Chicago: Western Historical Company, 1881.

regory, John G. *History of Milwaukee Wisconsin*. Chicago: S. J. Clarke Publishing Company, 1931.

aight, Theron W., ed. *Memories of Waukesha County*. Madison, WI: Western Historical Association, 1907.

ale, Frederick. *Swiss in Wisconsin*. Revised and expanded edition. Madison, WI: Wisconsin Historical Society Press, 2007.

istory of Washington and Ozaukee Counties, Wisconsin. Chicago: Western Historical Company, 1881.

istory of Waukesha County, Wisconsin. Chicago: Western Historical Company, 1880.

arty, Martin. *Dr. Johann Martin Henni, Erster Bischof und Erzbischof von Milwaukee*. New York: Benziger Brothers, 1888.

ilwaukee Daily Journal. 19th Century U.S. Newspapers. Digital Collection. Thomsen Gale Infotrac. Milwaukee Public Library. July 30, 2009.

ilwaukee Daily Sentinel. 19th Century U.S. Newspapers. Digital Collection. Thomsen Gale Infotrac. Milwaukee Public Library. July 30, 2009.

uickert, Carl. *The Story of Washington County*. West Bend: self-published, 1923.

einach, Dr. Adelrich. *Swiss Colonists in 19th Century America*. Camden: Picton Press, 1995.

ill, Bayrd. *Milwaukee: The History of a City*. Madison, WI: State Historical Society of Wisconsin, 1965.

atrous, Jerome A., ed. *Memoirs of Milwaukee County*. Madison, WI: Western Historical Association, 1909.

www.arcadiapublishing.com

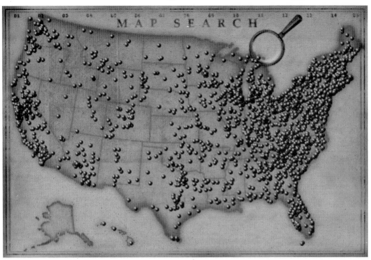

M A P S E A R C H

Discover books about the town where you grew up, the cities where your friends and families live, the town where your parents met, or even that retirement spot you've been dreaming about. Our Web site provides history lovers with exclusive deals, advanced notification about new titles, e-mail alerts of author events, and much more.

Find Your Place in History.